Maid, whom circling years improve,

object of her warmest love.

hours successive as they glide.

Needle, and the Pen, divide.

Abundant Harvest

SELECTIONS FROM THE GAIL-OXFORD COLLECTION OF AMERICAN DECORATIVE ARTS AT THE HUNTINGTON

THE HUNTINGTON LIBRARY,
ART COLLECTIONS,
AND BOTANICAL GARDENS
SAN MARINO, CALIFORNIA

Foreword

CATHERINE HESS
*Interim Director of the
Art Collections*

Henry and Arabella Huntington were famously passionate collectors of British grand manner portraiture and of European painting, sculpture, and decorative arts. American art seems to have interested them much less. The Huntingtons did acquire several important examples of American painting and furniture, which, not surprisingly, reflect their interest in the 18th- and early 19th-century styles that emanated from London, Paris, and Rome. The paintings they owned by American-born artists include a portrait by John Singleton Copley painted after the artist's move to London in the 1770s; a large composition on a Shakespearean theme by Pennsylvania-born artist Benjamin West, second president of the British Royal Academy; and a portrait of George Washington by Charles Peale Polk. Portraits of U.S. men of state were of particular interest, perhaps acquired to prepare their house for the day when it was to become a public institution. Among Henry and Arabella's few works of American decorative arts was an extremely rare card table made in New York by the celebrated French émigré cabinetmaker Charles-Honoré Lannuier.

When The Huntington's American art galleries opened to the public in 1984, more than 50 paintings and works on paper given in memory of collector and philanthropist Virginia Steele Scott complemented the few pieces that had been owned by Henry and Arabella. To broaden the displays of primarily painting and sculpture, the institution borrowed a sizable group of furniture from the Dietrich American Foundation in Philadelphia. This foundational interest in combining the decorative arts with painting and sculpture is now a guiding principle throughout The Huntington's American galleries.

Strategic acquisitions have expanded the American art collections since that time, thanks to the support of the Virginia Steele Scott Foundation, the inspired vision and dogged commitment of the Art Collections' directors and curators, the generosity of cherished donors, and the sustaining attention of The Huntington's Art Collectors' Council. With regard to American decorative arts, two of the most transformational events for The Huntington have taken place in the last two years. As a result of the generous bequest of Thomas H. Oxford and Victor Gail in 2016—joined by a magnificent gift of American art from Jonathan and Karin Fielding in 2017—The Huntington's American decorative arts collection has been vastly enriched.

This handbook offers an introduction to the Gail-Oxford Collection, which comprises more than 130 pieces and ranges in date from the mid-17th to early 20th century. The volume includes insightful commentary on 64 of the most significant works in the collection.

I want to take the opportunity to thank Curator of American Decorative Arts Harold B. "Hal" Nelson for securing this important gift. His long-standing friendship with Tom Oxford and Victor Gail was instrumental in bringing this extraordinary collection to The Huntington. I also want to acknowledge his commitment to producing this handbook, which we hope will provide a useful introduction to the Gail-Oxford Collection and reflect the richness and diversity of The Huntington's holdings.

Introduction

HAROLD B. NELSON

Curator of American Decorative Arts

Thomas H. Oxford (1927–2008) and Victor Gail (1929–2014) began their decades-long commitment to American art in 1968 when they purchased a handsome high chest of drawers made in Salem, Massachusetts, in the mid-1700s. In 40 years, they amassed one of Southern California's finest collections of early American decorative arts. They gave much of that collection—more than 130 examples of painting, sculpture, furniture, ceramics, metalwork, and textiles—to The Huntington as a bequest. It is now exhibited in the Virginia Steele Scott Galleries of American Art as the Gail-Oxford Collection.

By Gail's own account, he was the more acquisitive of the two, whereas Oxford was the true historian. As Gail stated in 2011, "Tom loved to research each piece, particularly when it involved provenance—the history of ownership. Even to this day I find little pieces of paper tucked away in drawers, notes recording Tom's observations on the piece and its history."

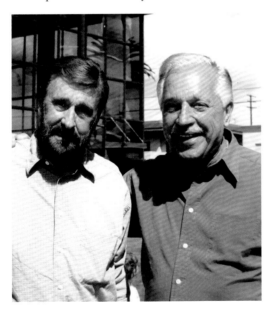

Gail and Oxford lived with these objects in a modest home in Long Beach, California, where they regularly augmented, refined, and rearranged the collection. Their gift to The Huntington was as much a celebration of the 60 years they spent together as a reflection of their shared values and priorities.

Among the highlights of the Gail-Oxford Collection are a high chest of drawers, thought to have been made in New York around 1710; a block-front desk-and-bookcase made in Massachusetts around 1775; another high chest made in Wethersfield, Connecticut, between 1780 and 1790; and a needlework sampler by Anne "Nancy" Moulton from 1796.

FURNITURE

Gail and Oxford were particularly interested in furniture made in New England between 1720 and 1800. Although they collected spectacular examples of high-style, urban design, such as the Massachusetts secretary and bookcase, they were primarily interested in rural, vernacular traditions, and marvelous representations of regional forms abound. Among these are a New Hampshire chest of drawers, a handsome New England dressing table, and numerous pieces of seating furniture made in New England, New York, and Pennsylvania.

CLOCKS

The two also had a keen interest in clocks, and several examples of British- and American-made timepieces are now at The Huntington. These range from a wall-mounted brass lantern clock made in London around 1650—one of the earliest pieces in the collection—to two large, floor-standing tall case clocks and an early patented banjo clock by Simon Willard.

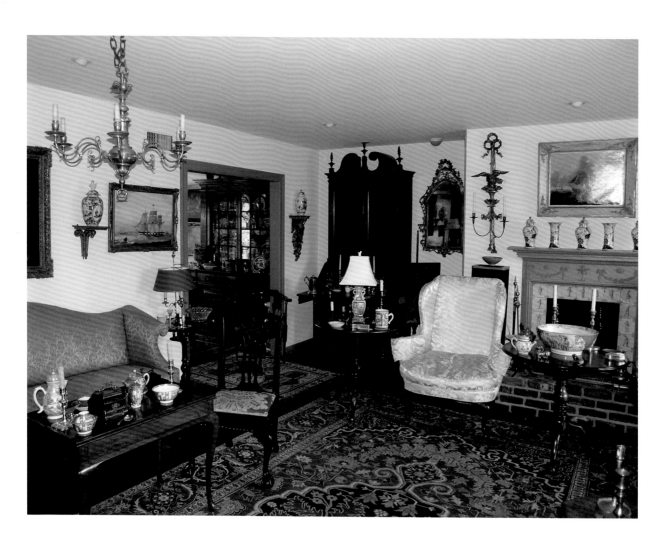

FIG. 2.

Living room,
Gail-Oxford
residence, Long
Beach, California,
around 2005.
Photo: Harold B.
Nelson

CERAMICS

Ceramic objects comprise the largest group of works in the collection. Most of the so-called "redware" (lead-glazed earthenware), such as the wonderful ABC, DE, and mince pie dishes, is American-made. Many of the other ceramics were made in England or northern Europe but would have been found in American homes in the 18th and early 19th centuries. The Gail-Oxford Collection includes a large group of British and Dutch delftware (tin-glazed earthenware), some 19th-century British ceramic sculpture—made in Staffordshire especially for the American market—and a Chinese export porcelain tea service.

NEEDLEWORK

Marvelous examples of British and American needlework include an extremely rare coat of arms, "By the name of Ives," from 1763; a stitched and painted memorial to Captain John Allen from 1811; and a family tree of the young needle-worker Elizabeth Stone, made in 1820. In addition to this rich body of material, the collection features four quilts and a jacquard coverlet that was signed in 1847 by the Scottish-born, Indiana-based weaver Samuel Balantyne.

PAINTINGS

Notable paintings include a portrait of Margaret Chew Bordley, the wife of an 18th-century Maryland planter, painted around 1752 by the British-trained artist John Wollaston, and a double portrait of a brother and sister painted by Joseph Goodhue Chandler around 1850. Although most of the paintings are portraits of specific individuals, a dynamic composition by the British artist Thomas Buttersworth, Sr. portrays a lively seascape.

OTHER MATERIAL

The Gail-Oxford Collection also features a significant number of objects that, while made for everyday use, rise to the level of fine sculpture. Examples include a monumental burl wood bowl, a weathervane, and a decorated horn made to store gunpowder.

In addition to offering The Huntington their collection, Gail and Oxford contributed the remainder of their estate to endow a curatorship dedicated to the American decorative arts field. In recognition of this gift, two galleries have been named in their honor, and the position will be called the Gail-Oxford Curator of American Decorative Arts.

This handbook presents an overview of the Gail-Oxford Collection, highlighting 64 of its most notable objects. It is intended to provide a thoughtful introduction and insight into this marvelous addition to The Huntington's growing collection of American art.

Catalog

Lantern clock

about 1650

—

Benjamin Hill (1617–about 1670)
England
Brass, steel, and rope
14¾ × 5¾ × 5¾ in.
2016.11.1

—

Though 17th-century documents describe this form of timepiece as a "chamber" or "house" clock, it was given its current name because of its resemblance to a lantern. First introduced to England about 1610, it was the most typical form of domestic clock in the American colonies for over a century. However, because of its cost, it was found only in the most affluent households, as a symbol of its owner's wealth and social standing.

This lantern clock, like others of the period, was controlled by a balance wheel. However, after pendulums were introduced in the 1660s, they were added to clocks to regulate time more precisely. The floral and tusked boar-whale designs in the brass fretwork above the dial were common motifs in lantern clocks. The tusked boar-whale motif was probably inspired by engravings of giant sea creatures in Conrad Gessner's *Historia animalium* (History of the animals; 1551–58).

Benjamin Hill, baptized in 1617, was the son of a wheelwright. He was apprenticed to the clockmaker Richard Child in 1632. In 1640 he was made a Free Brother of the Clockmakers' Company, a guild founded in 1631 to ensure a consistently high quality for all British-made clocks. Hill's workshop on Fleet Street was destroyed in the Great Fire of London in 1666; he subsequently moved to Fetter Lane. The engraving of Hill's name and Fleet Street address on the dial indicates that this clock was made prior to the 1666 fire.

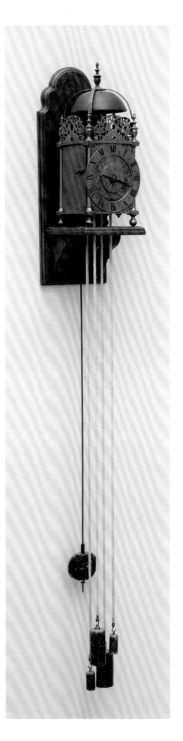

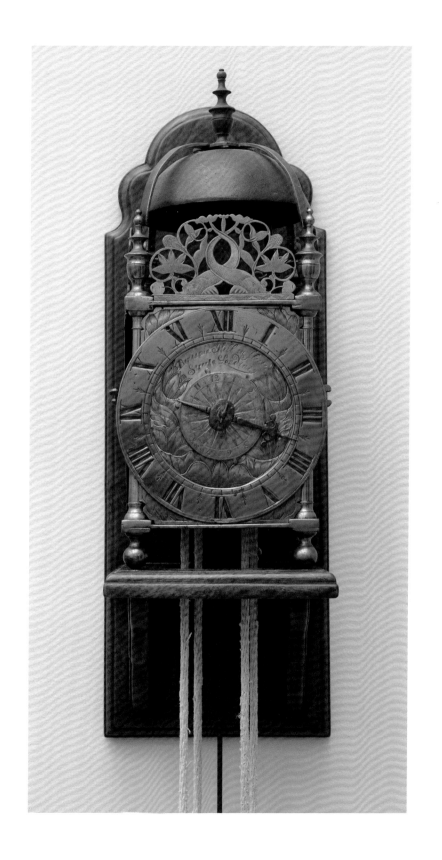

Sacrifice of Isaac

late 17th century

England
Silk and silver-wrapped thread on linen
11 × 17 in.
2017.5.22

Throughout the 17th and 18th centuries, affluent young women in England and its American colonies studied the intricacies of fancy needlework. Their elaborately detailed compositions, often based on prints, frequently depicted Old Testament themes of piety and submission to the will of God.

The subject of Abraham preparing to sacrifice his son Isaac upon God's command (Genesis 22:9–13) was very popular in 17th-century needlework. This particular image of devotion is based on an engraving after Maarten de Vos's *Sacrifice of Isaac* that was published by Gerard de Jode in *Thesaurus sacrarum historiarum Veteris Testamenti* (Treasury of sacred events from the Old Testament; 1585), a source for many needlework designs in the following century. The engraving and needlework composition depict the same narrative, with the angel staying Abraham's hand, preventing him from slaying his son. However, the lake at the left of the composition, with its exotic flora and fauna, was added to the needlework version. Like the array of beasts, insects, and blossoms in the borders that surround the central panel, these additions symbolize the abundance of the natural world.

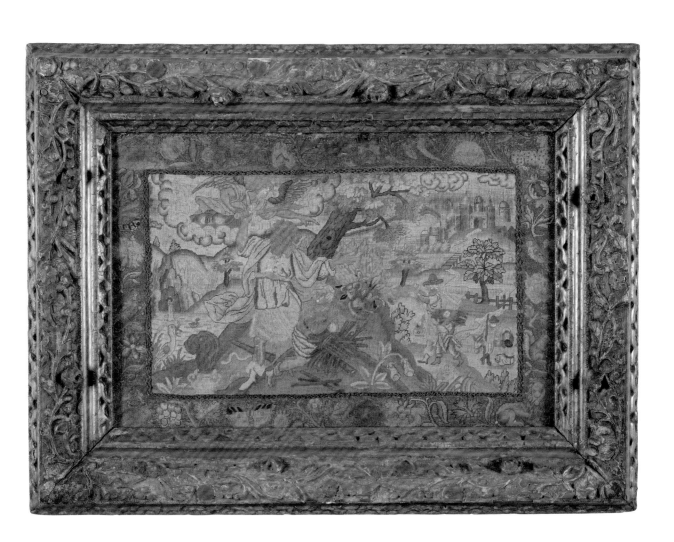

Scenes from the life of Abraham

late 17th century

England
Silk on linen
9½ × 13½ in.
2017.5.19

Like the previous entry, *Scenes from the life of Abraham* is based on an engraving in Gerard de Jode's *Thesaurus sacrarum historiarum Veteris Testamenti* (Treasury of sacred events from the Old Testament; 1585). While more explicit in its details, the engraving portrays the same scenes as the 17th-century needlework composition. As with the *Sacrifice of Isaac*, the themes of this Old Testament story are faith and man's submission to the will of God.

According to the biblical narrative, before giving birth to Isaac, Abraham's wife Sarah thought she was barren. To ensure that her husband had heirs, she encouraged him to conceive a child with her Egyptian maidservant, Hagar. Hagar bore Abraham a son named Ishmael. Sarah subsequently saw Ishmael as a threat to her son and told Abraham to cast Hagar and Ishmael off into the wilderness. He did, and just as Ishmael was about to die of thirst, the angel of God showed them a well (Genesis 21:9–19).

Three pivotal moments in the narrative are portrayed in this needlework composition: Sarah holding Isaac's hand and telling Abraham to cast Hagar out; Abraham sending Hagar and Ishmael into the wilderness; and the angel directing the prayerful Hagar and fast-fading Ishmael to water. The landscape is full of plants, flowers, birds, and insects, indicating the bounty of nature.

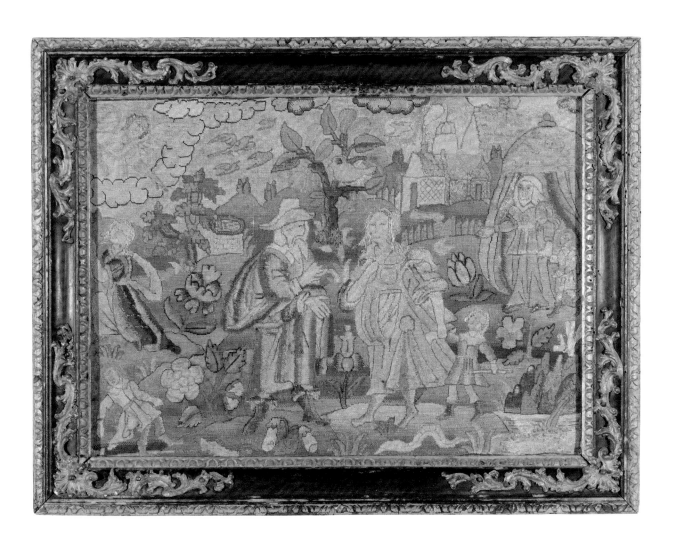

Armchair

about 1700

————

New York
Maple, hickory, and rush
48½ × 26 × 19½ in.
2017.5.67

————

By 17th- and early 18th-century standards, this armchair would have been considered a very grand piece of seating furniture. Because of its importance, it would most likely have been reserved for the eldest member of the family, the head of the household, or the most honored guest. Sometimes referred to as a "great chair," it would also have been considered among a family's most valued home furnishings.

With its heavy vertical posts, sausage-shaped front stretchers, elaborately turned rails under knife-blade arms, and beautiful vase-shaped finials, this ladder-back chair was probably produced in New York. There, Dutch and Flemish decorative arts traditions were influential in the 17th and 18th centuries. The use of four slats on the chair back and the highly sculptural turnings are also typical of chairs produced in New York. Chairs such as this were made somewhat more comfortable through the use of cushions or "squabs."

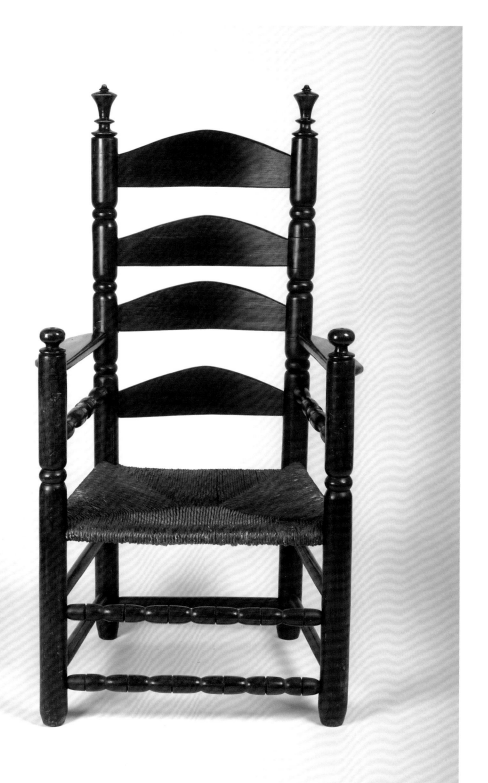

High chest of drawers

about 1710

———

Possibly New York
Walnut, yellow pine, eastern white pine,
burl ash veneer, and brass
57¼ × 39 × 20½ in.
2010.8

———

High chests of drawers, storage cases raised up on tall, slender legs, were a design innovation of the Baroque period. Used in 18th-century American homes to store linens, clothing, and other valuable textiles, they were typically placed in bedchambers and often paired with dressing tables of similar design.

In their soaring verticality, high chests of drawers represent a dramatic alternative to the ponderous weight and horizontal massing of earlier forms. Their visually rich surfaces—often created through the application of ornate burl veneers—further invigorate the furniture of this period.

With its spiral legs, early dovetailed board construction, original brasses, and rich burl ash veneer, this high chest is among the most unusual pieces in the Gail-Oxford Collection. Spiral legs on high chests of this period, while rare, are associated with New York, where the influence of Dutch and Flemish design traditions continued well into the 18th century.

In this deftly composed high chest, the graceful curves of the stretcher echo the lines of the skirt in the lower case. The flat top of the upper case provides a platform for displaying delftware, porcelain, or other ornamental wares.

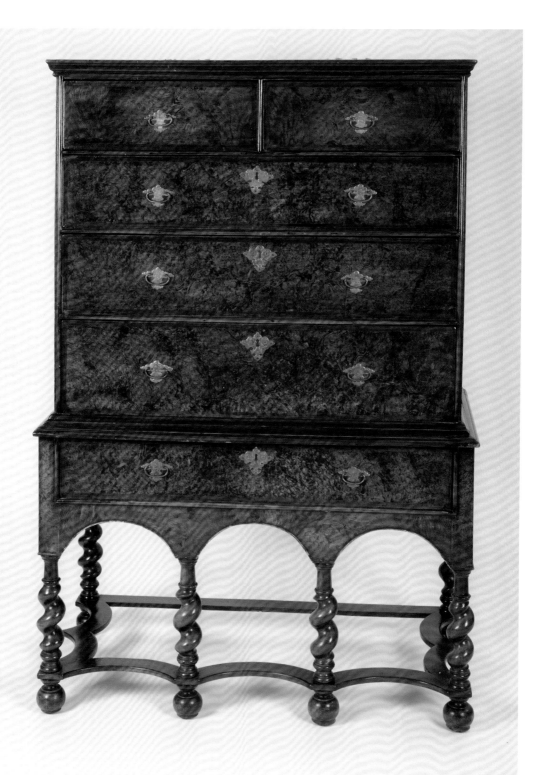

Dressing table

1720–30

———

New England
Walnut, pine, walnut veneer, and brass
28½ × 32½ × 20 in.
2016.11.2

———

In the 18th century, dressing tables were used by women for applying makeup and dressing and were often paired with high chests of similar design. This dressing table with three side-by-side drawers reflects the formal and structural innovations of Baroque style, first introduced to America in the early 1700s. The walnut veneers decorating the table's surface add visual richness to its overall composition. The attenuated legs—with their somewhat unsettling juxtapositions of diminutive vase-shaped turnings, inverted cups, and up-turned trumpets—suggest a Baroque aesthetic that emphasized mystery, drama, and disquiet. The X-shaped stretcher and acorn-shaped drop finials are also typical of this style.

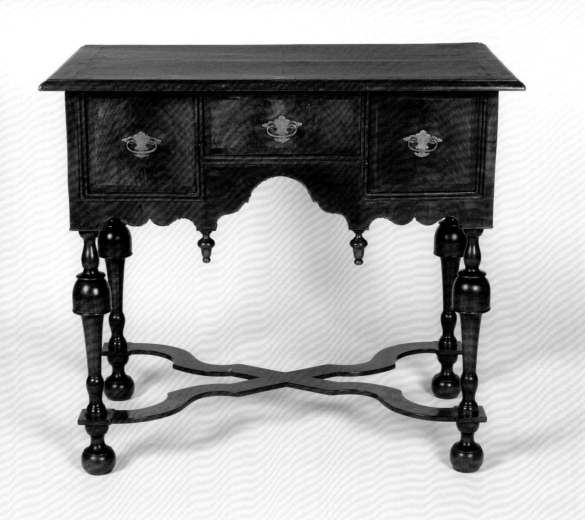

Oval table with falling leaves

1720–30

Possibly Pennsylvania
Maple and pine
Open: 29½ × 64¾ × 54 in.
Closed: 29½ × 21 × 54 in.
2016.11.3

Known today as "gateleg tables," tables with falling leaves were among the most versatile forms of furniture found in American homes in the 17th and 18th centuries. First appearing in household inventories in the late 1660s, these tables had auxiliary legs that swung like gates beneath the surface to support hinged leaves. When not in use, the leaves were typically lowered to the side, and the table was placed against a wall. Unlike earlier rectangular tables, which were massive, heavy, and less easily moved, oval tables had no true head, reflecting newer, less formal dining customs and less rigid social hierarchies.

With elaborately turned balusters, rings, and reels forming its legs and stretchers, this table exemplifies the vibrant energy seen in American furniture of the Baroque period. Its two drawers, one under each end of the top center section, provide a further note of practicality to this highly versatile form.

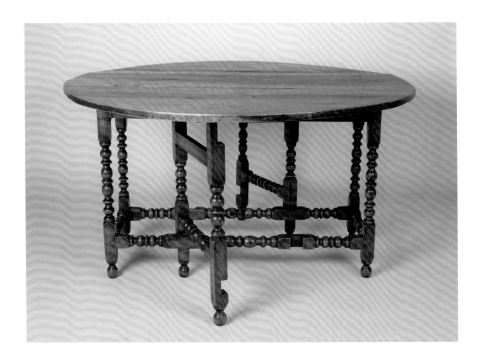

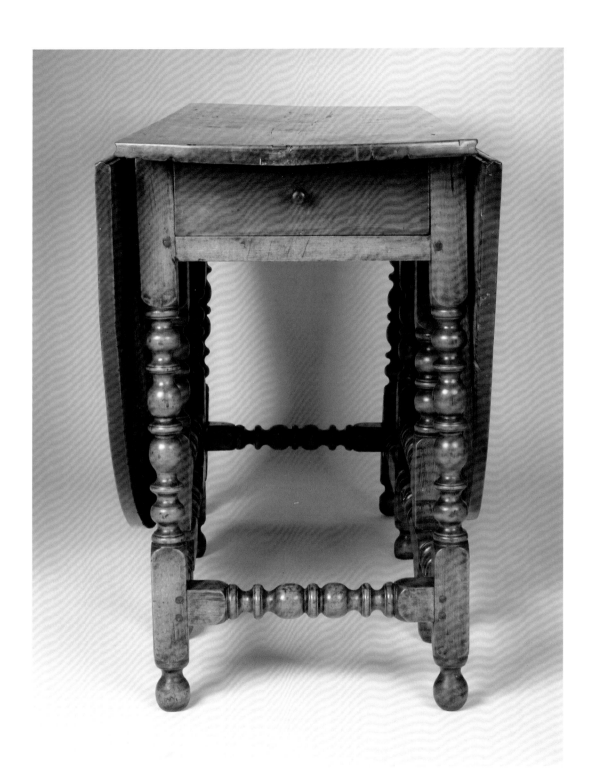

Box

1745

————

Possibly America
Oak with traces of paint
5 × 16½ × 12¼ in.
2017.5.28

————

Lidded wooden boxes with carved decorations on the front panels were commonly found in American homes in the 17th and early 18th centuries. Used to store a variety of materials—including writing implements, personal items, currency, and valuable documents—they were typically lockable.

This box is somewhat unusual in that it is decorated on all four sides with ornate floral and foliate carving, and it lacks a locking device. It also has traces of yellow, green, red, and white pigment, suggesting that it was once elaborately painted. Spear-shaped strap hinges secure the lid to the box.

The letters "I M C" are probably the initials of the box's original owner; "1745" refers to the year in which it was made. The interior of the box has a long compartment with a hinged lid that was possibly used for writing implements.

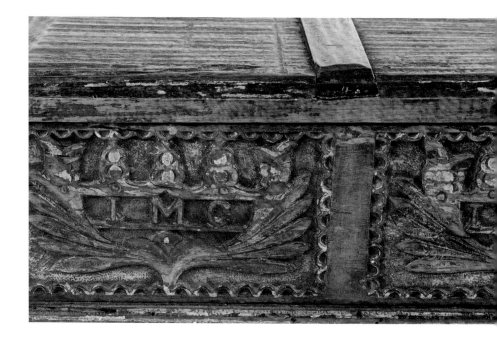

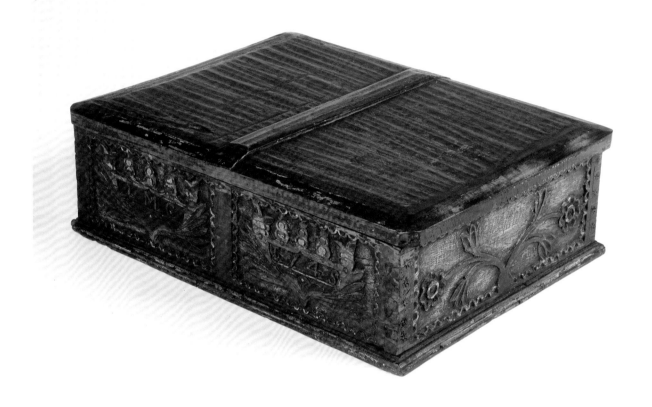

Couch

1720–40

————

Pennsylvania
Maple with traces of paint, wool
39½ × 66 × 23 in.
2017.5.26

————

A couch, later known as a daybed, was an elongated seat with a single back at one end. Derived from the French *lit de repos*, the form became popular in America in the last quarter of the 17th century. While produced throughout the first half of the 18th century, the couch was, according to contemporary household inventories, rather expensive and considered a luxury item.

Used as an extra bed, a bench to accommodate several people, or a seat for solitary reclining, such a couch was, like many 17th- and 18th-century furniture forms, highly versatile. While some had fixed backs, others were hinged and could be adjusted through the use of chains. Some seats were made of rush or cane, while others had woven fabric straps and upholstered cushions. Fabric-covered pads or "squabs" like the modern one included here were used to cushion the seat and back.

With its bannister back with arched crest rail and its robust turned legs and stretchers, this piece is typical of Pennsylvania-made forms. There is a similar couch in the collection of the Metropolitan Museum of Art in New York.

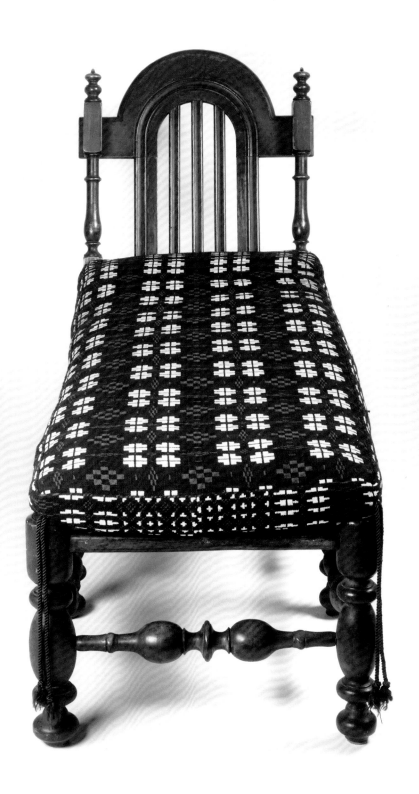

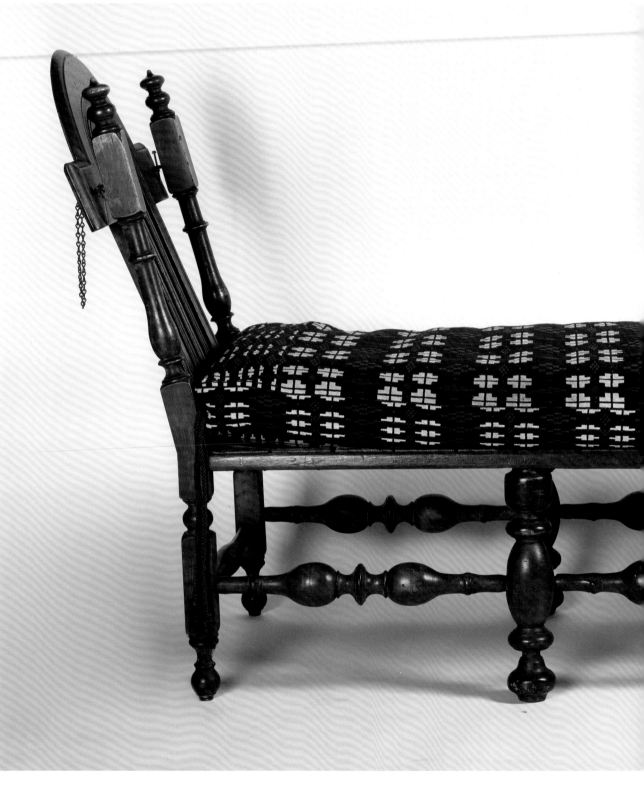

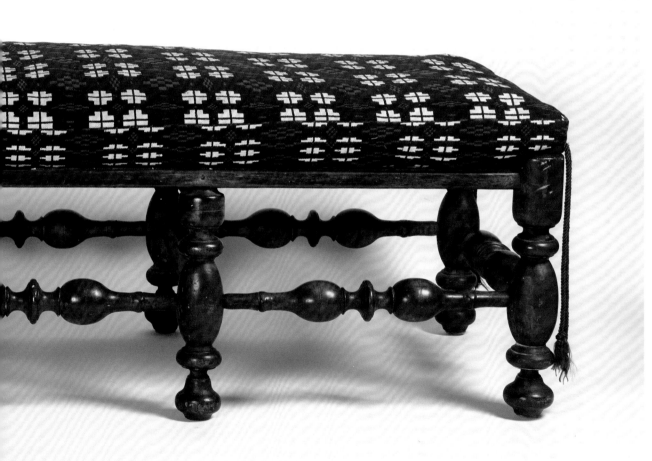

High chest of drawers

about 1780–90

———

Wethersfield, Connecticut
Cherry, white pine, and brass
84 × 37½ × 20¼ in.
2013.8

———

In most 18th-century homes, clothing was either hung from hooks on a wall or folded and placed in lockable chests of drawers. According to household inventories of the period, textiles were among the most valuable items in the home. Until late in the century, most were imported to America, which added greatly to their cost.

This high chest, produced in the final quarter of the 18th century, reflects its original owner's wealth and social standing. Note the sweep of the broken-scroll pediment, along with the graceful vase-shaped finials, carved sunburst on the plinth supporting the central finial, delicately carved fans on the upper and lower central drawers, gently curving skirt, and especially the elongated proportions of its elegant cabriole legs. All of these elements associate this chest with 18th-century cabinet-making traditions in Wethersfield, Connecticut, a community on the Connecticut River southeast of Hartford.

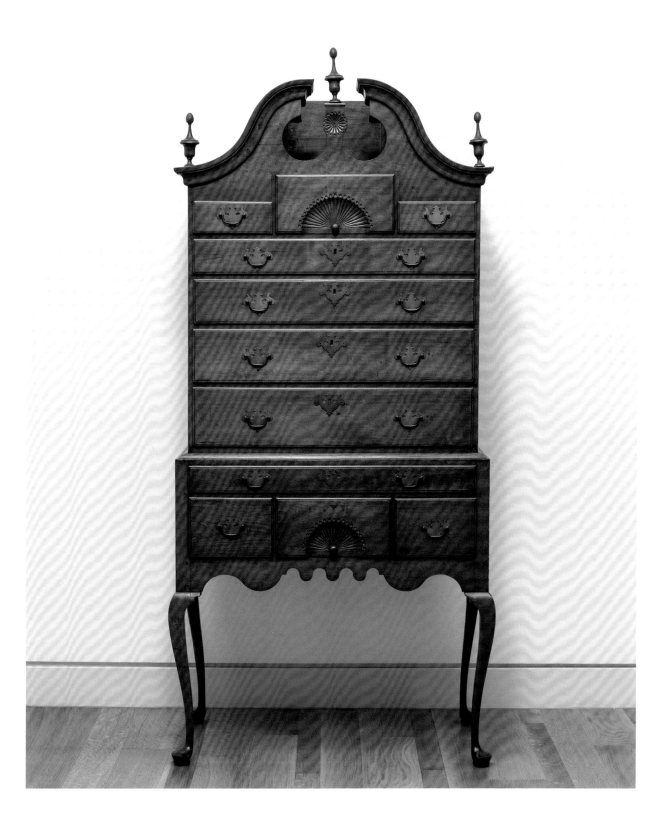

Dressing table

1750–60

———

New England
Maple, pine, and brass
30½ × 31½ × 21 in.
2016.11.4

———

This dressing table—with its elegantly curving cabriole legs and pad feet, its carved fan motif on the central drawer, and its mid-rib drops in a distinctive acorn shape—is a fine example of American furniture in the late Baroque style. The table was most likely used by a woman while applying her makeup and dressing her hair.

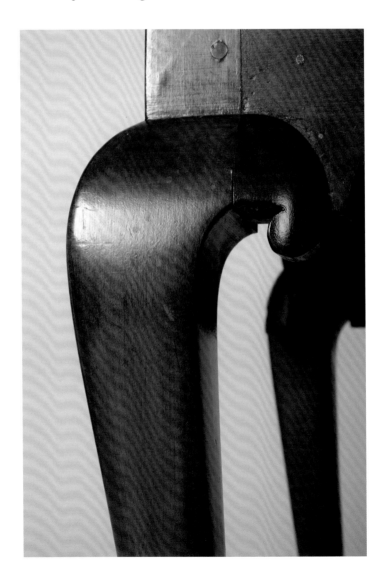

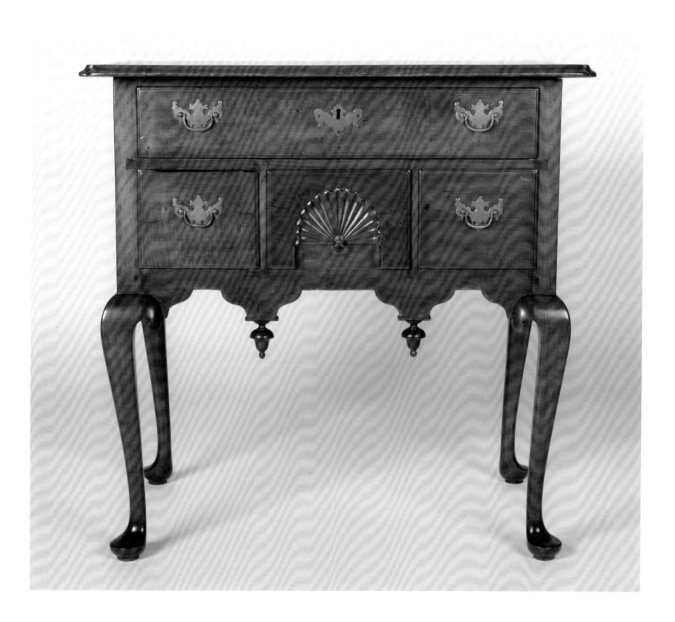

Chair

1730–60

———

Massachusetts
Walnut and silk
40 × 22 × 20 in.
2016.11.18

———

This walnut side chair, with its cabriole legs and pad feet, reflects the Queen Anne or Late Baroque style popular in New England in the mid-18th century. Often made in matching sets, chairs such as this were lined up against the wall when not in use. This one has four notches carved inside the front seat rail, indicating that it was once part of a set.

This beautifully proportioned example, with its vase-shaped back, gently curving, scalloped front seat rail, and broad pad feet, is typical of Boston-made chairs. However, the front stretcher—featuring an attenuated double vase-and-ring design—is quite unusual for the period. It may reflect the chair's rural origins or the more conservative taste of its original owner or maker.

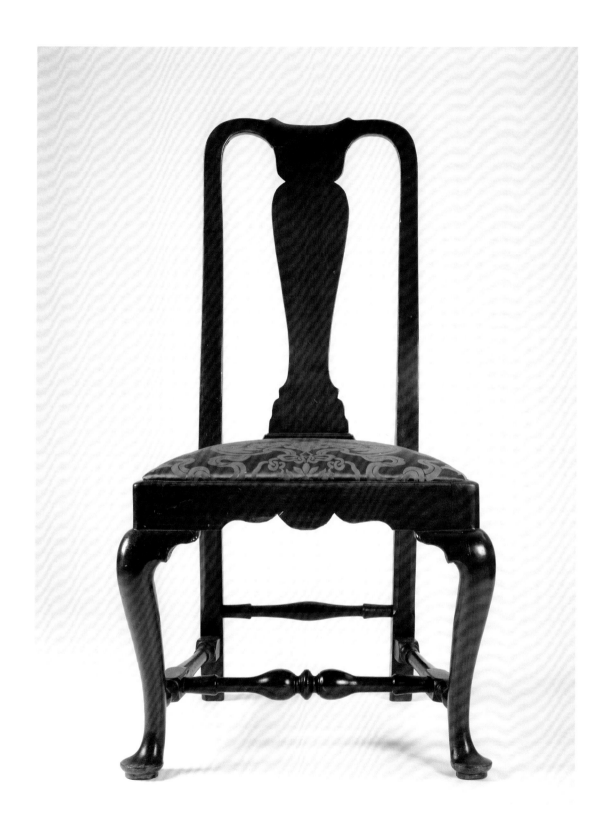

Chair

1730–60

———

Massachusetts
Walnut and wool
39½ × 20½ × 20 in.
2017.5.70

———

With its elongated vase-shaped splat and its cabriole legs, this chair is similar to the previous entry. Distinguishing features include the "stiles" or back posts with flattened front faces and the rounded compass seat.

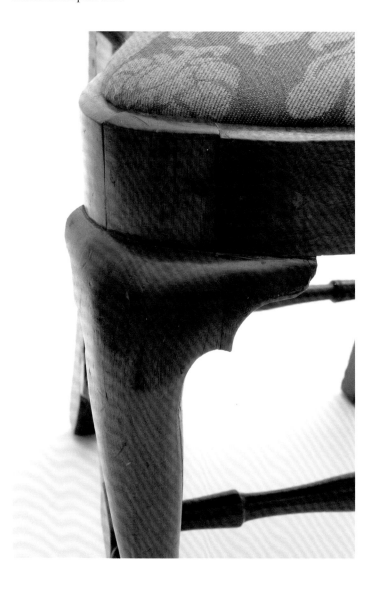

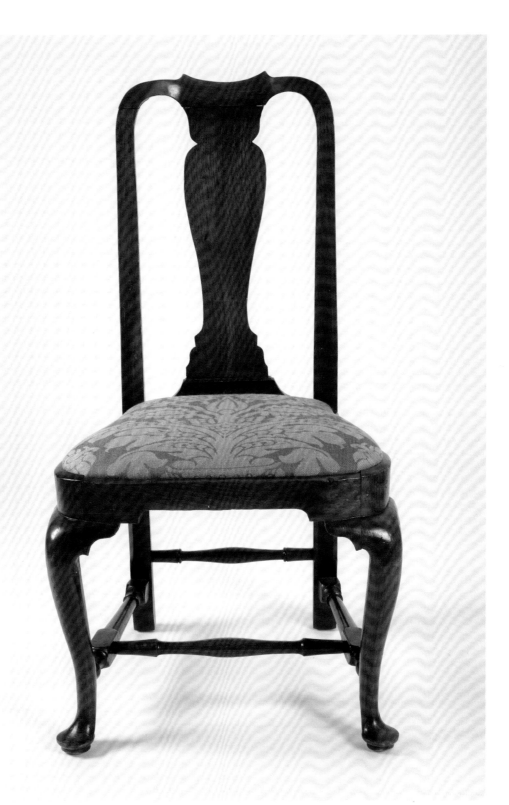

Tea table

1740–60

———

Newport, Rhode Island
Mahogany
25¾ × 32¼ × 20¾ in.
2016.11.5

———

Tea tables first appeared in household inventories in America in the early 1700s. Relatively small, low, and lightweight, they could be placed in the center of a room and easily set aside when not in use.

This tea table, with its graceful cabriole legs and elongated slipper feet, is typical of those produced in Newport in the mid-18th century. The spare, restrained beauty of this form is a fundamental characteristic of Rhode Island furniture.

The molding around the perimeter of the top emulates the trays from which these moveable furniture forms evolved. The protective lip prevented the tea equipage—such as the teapot, cups, saucers, creamers, sugar bowls, and waste bowls—from sliding off of the surface when the table was in use.

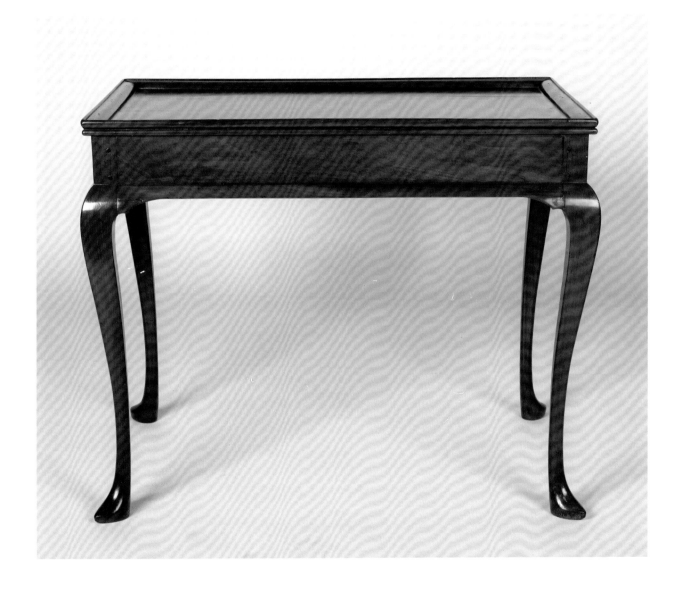

Tea service

about 1800

China
Porcelain
Teapot: 5½ × 7½ × 4¼ in.
Tea jar: 5¼ × 3 in.
Covered bowl: 3¼ × 4½ in.
Teacup: 1⅞ × 3 in.
Saucer: ¾ × 5 in.
Waste bowl: 2⅜ × 5¼ in.
Hexagonal dish: ¾ × 5½ in.
Caddy spoon: 2½ × 2 × 3¼ in.
2017.5.5.1–.13

Serving and drinking tea at home became enormously popular in America after the mid-18th century. Like the tea itself, many of the implements, dishes, and pots used were imported from China or influenced by forms brought to America through trade with Asia.

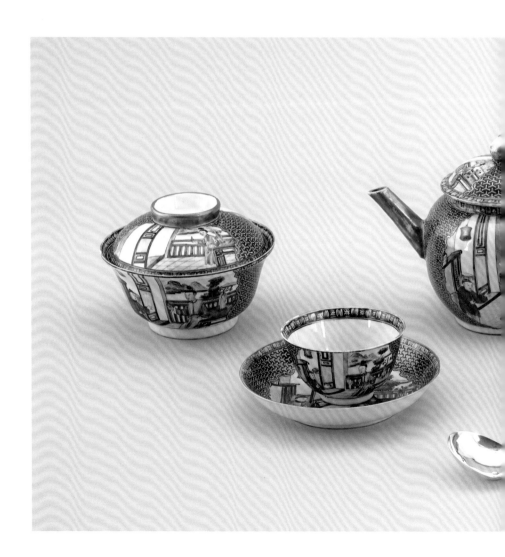

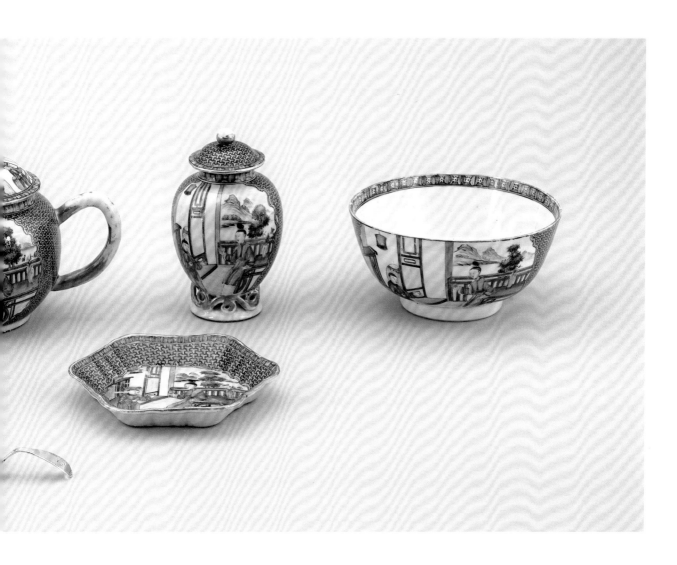

Posset pot

1720–40

England
Tin-glazed earthenware
7½ × 10 in.
2017.5.64

Tin-glazed earthenware—known as "delftware"—gained widespread popularity in England in the late 17th and early 18th centuries. Its bold blue-on-white designs emulated the decorative motifs and color palette of Chinese porcelain, which had been introduced to Europe and England through trade with Asia.

Delftware was first listed in household inventories in America around 1680. Popular in both the English and Dutch colonies, it appeared in 18th-century homes from the rural areas of the Connecticut River Valley to the urban areas of New York, Philadelphia, and Boston. Delftware reflects the complex blending of tastes, styles, and international influences that shaped America's diverse cultural history in its earliest years.

Posset was a soupy beverage made by mixing warm milk or cream with wine or ale. Pieces of bread and spices were often added to thicken and give flavor to the curdled, pudding-like mixture. The whey was poured or sipped from the spout, and the curds were eaten with a spoon. Given the rather large size of this vessel, it may have been passed around a table and used by several people.

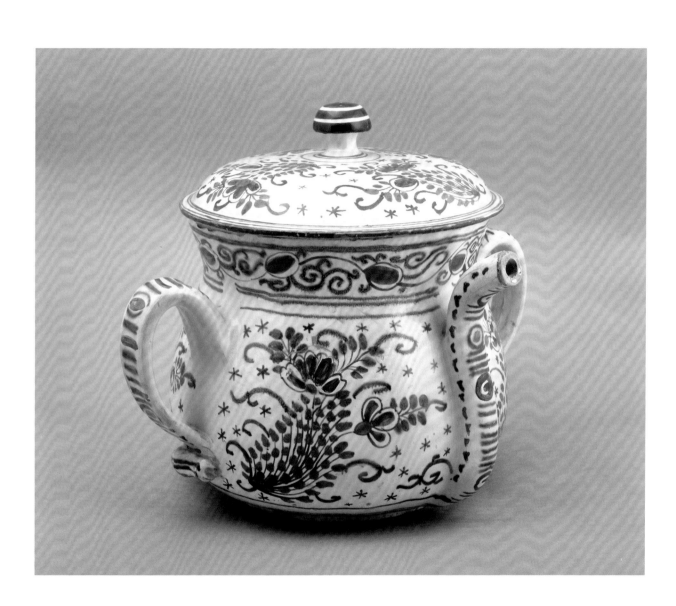

Easy chair

1750–60

Massachusetts
Walnut with maple rear legs,
and silk
46½ × 35½ × 25½ in.
2016.11.6

According to 18th-century household inventories, easy chairs, known today as "wing chairs," were often placed in bedchambers and upholstered in imported fabrics that matched the room's curtains and bed hangings. Introduced to America in the 1720s, they were frequently reserved for the most important members of the family, the elderly, or the infirm.

This chair, with its relatively flat crest rail, wings that slope down to inverted cone-shaped arms, trapezoidal seat with rounded corners, turned stretchers, and cabriole legs with raised pad feet, is typical of easy chairs made in New England in the mid-18th century. The upholstery is a 20th-century reproduction of an 18th-century fabric.

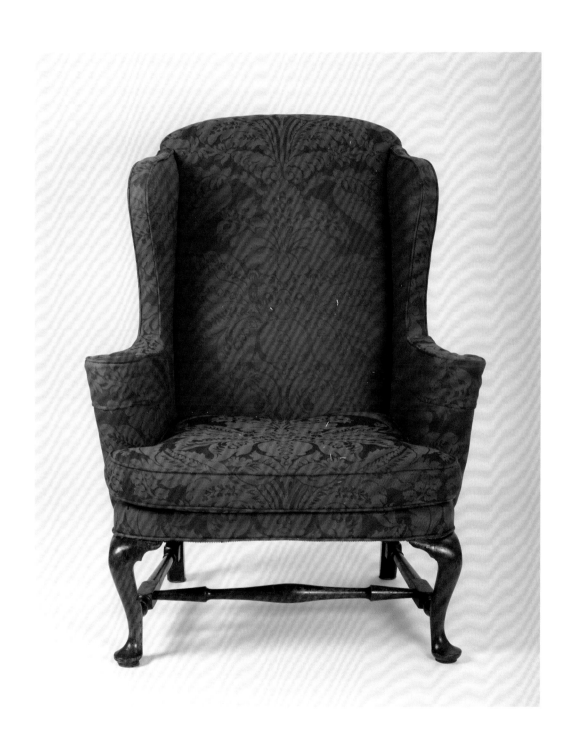

Stand

1740–80

Philadelphia
Mahogany
28 × 22 × 22 in.
2016.11.9

Many 18th-century furniture forms were versatile and lightweight so that they could be easily moved around a room. This table, with its relatively small top, might have been used as a candlestand, a tea table, a game table, or a surface for small meals. With a metal hinge that allowed the top to be moved from a horizontal to vertical position, this stand could be stored against a wall when not in use. The molded rim of its circular top, the small baluster-shaped pillars of the "birdcage" or box, and the elegant, thin ankles of the tripod base are all typical of stands made in Philadelphia in the second half of the 18th century.

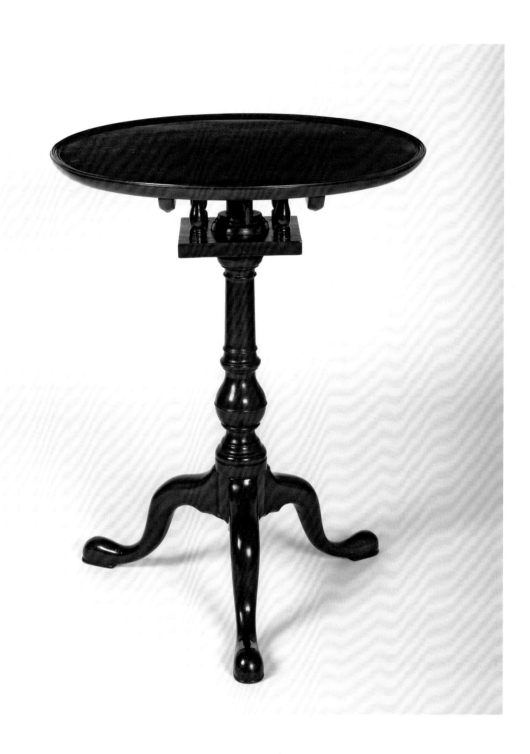

Armchair

1720–50

———

Delaware River Valley
Maple and rush
47½ × 23½ × 20 in.
2017.5.11

———

Tall, narrow, slat-back chairs were very popular in America in the second quarter of the 18th century. Often made in sets of six or eight and decorated in a variety of paint colors and finishes, they were produced in both rural and urban shops. Rush seats such as the one seen here could be ordered in a variety of weaves and in degrees of quality ranging from fine to superfine. Prices varied accordingly.

This handsome chair has elegant, pointed, bulb-shaped finials, five graduated slats with a gracefully arched profile on both the top and bottom edges, and a double vase-and-ring stretcher. These features are typical of chairs produced in Pennsylvania, New Jersey, and throughout the Delaware River Valley.

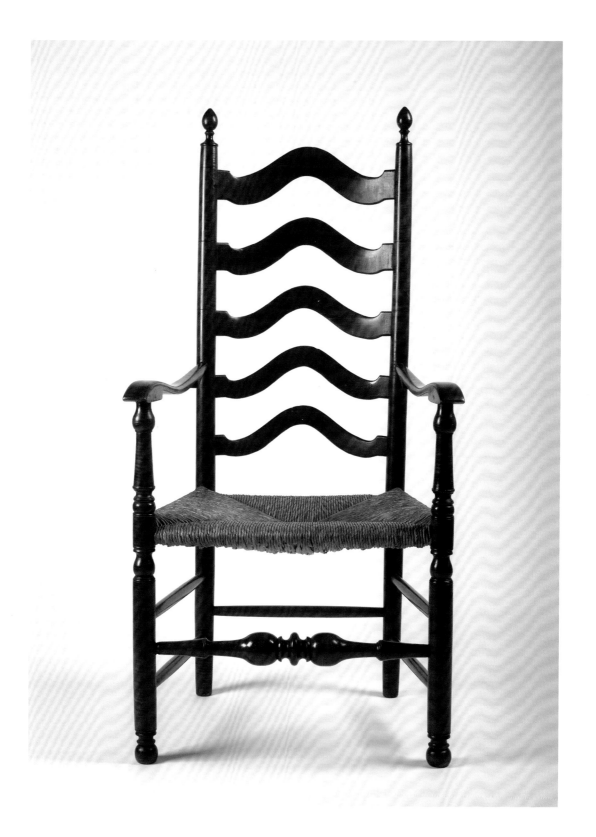

Desk

about 1780

———

New England
Flame birch, pine, and brass
42 × 36 × 18 in.
2017.5.1

———

Introduced to America about 1720, the form of desk known today as a "fall-front" or "slant-lid" desk evolved from a combination of a chest of drawers and a portable writing box with a sloping lid. Containing numerous drawers of various sizes and cleverly concealed storage compartments, it was the 18th-century equivalent of a workstation and lockable safe. Typically, the hinged front lid dropped down to form a writing surface supported by horizontal lopers that slid out from either side.

In the interior of this desk, the central prospect, decorated with an ornately carved shell, is flanked on either side by colonnettes that conceal storage compartments and a series of pigeonholes and drawers. Desks like this were used primarily by men conducting business affairs in the home.

According to the documentation accompanying this piece, the desk was purchased in 1781 by Robert Endicott (1756–1819), whose ancestor John Endicott (1588–1665) was governor of the Massachusetts Bay Colony. The documentation—a note from Robert Endicott's son William—states that it was purchased about the time his parents were married on November 1, 1781, and that they paid "nine hundred dollars (in Continental money)" for the brasses alone. The desk was passed down through generations of the Endicott family.

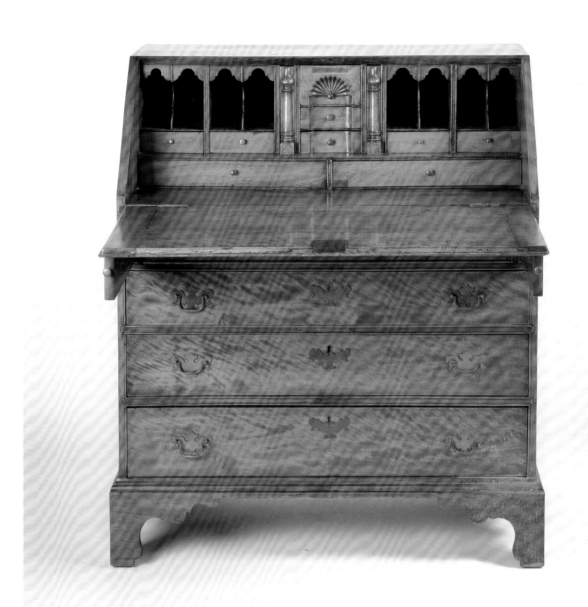

Windsor armchair

1780–1800

————

New England
Maple, hickory, pine, and paint
40 × 24½ × 17½ in.
2017.5.27

————

The Windsor chair, among the most popular forms of seating furniture in America in the late 18th century, appeared in both affluent and middle-class homes. Though the origins of the term are uncertain, the name "Windsor chair" first appeared in inventories in England in the 1720s and in America around 1740.

Simply constructed and highly practical, this type of chair has a flat plank seat, usually made of pine; turned legs, stretchers, and back posts or "stiles"; and long spindles typically made of oak, hickory, or ash. The various members are fitted into holes bored into the plank to form the back and support the seat.

This "fan-back" armchair, named for its high, outward-flaring back support, is unusual because of the elaborate turnings in its back posts, both above and below the arms; the elegant carving of "ears" at either end of the serpentine crest rail; the knuckle handholds at the end of each arm; and the rectangular block where the arms join the back posts. These features are typically associated with chairs made in coastal New England, particularly Nantucket.

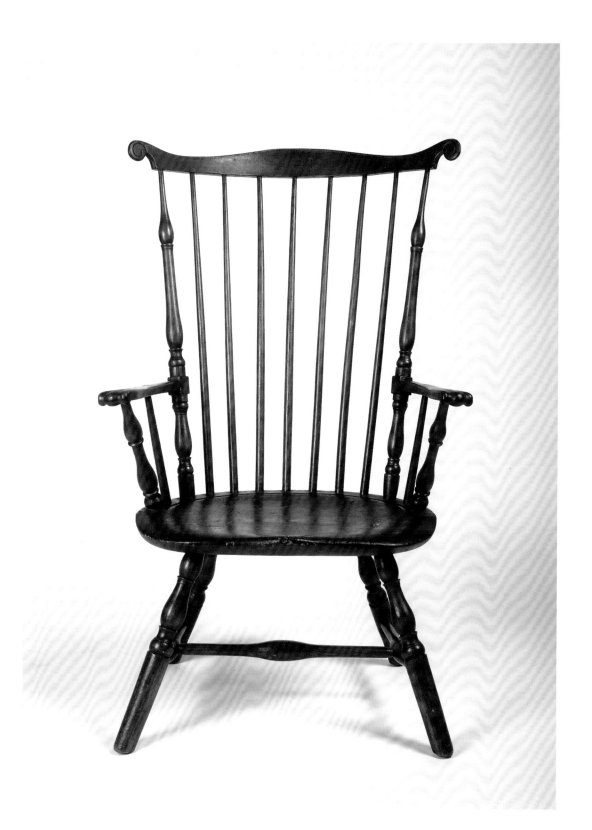

Candlestand

1735–50

―――

Iron and brass
62½ × 20 × 17 in.
2017.5.6

―――

Throughout the 18th century, candles were used in American homes in the evening or early morning hours to supplement light from the fireplace. Grease and tallow were among the least expensive materials used for making candles, though they were smoky and gave off a terrible odor. Beeswax or bayberry candles, while costlier, burned cleaner. Because of their expense, candles were often made at home. Even an individual as distinguished as Edward Holyoke, president of Harvard College, reported in his diary on March 22, 1743, that he was making 112 bayberry candles and 62 tallow candles for his personal use.

Three-legged, floor-standing iron candlestands such as this were versatile in that they could be easily carried from room to room. The candle height could be adjusted to suit particular lighting needs.

This graceful stand, with its ornate brass rings and finial, would most likely have been reserved for use in the most formal room of the home. The fine brass detailing would have amplified the light emitted by candles.

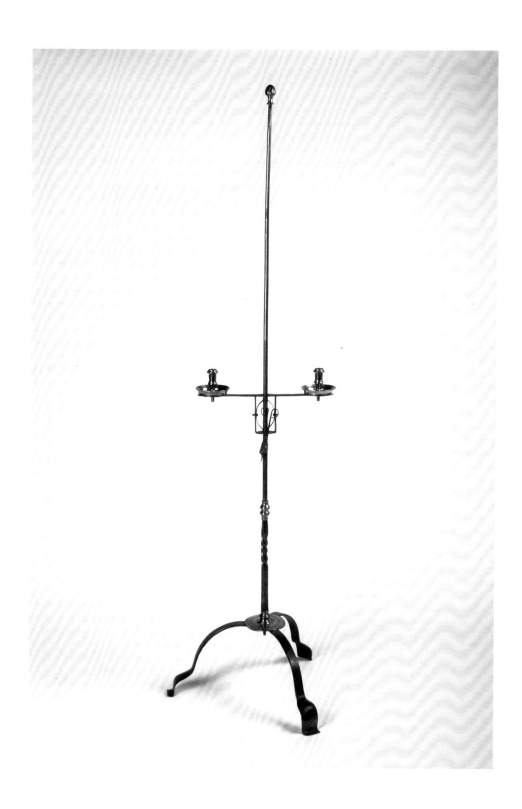

Bowl

about 1770

New England
Ash burl
9 × 26 × 17⅝ in.
2017.5.7

Because of its easy availability and low cost, wood was frequently used in early America to make tableware such as plates, bowls, and cups, as well as eating and serving utensils. So-called "treen" or "woodenware" was typically either turned on a lathe or carved by hand. Though considerably less sanitary than its ceramic counterpart, a wooden vessel was more durable and less prone to break, chip, or crack.

Hand-carved vessels such as this monumental bowl are thought to have been made by Native Americans in New England in the 18th and early 19th centuries. Bowls of this size, produced from a single ash burl, are rare.

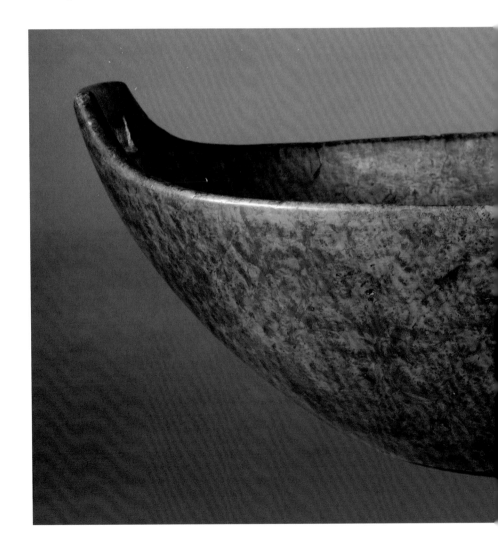

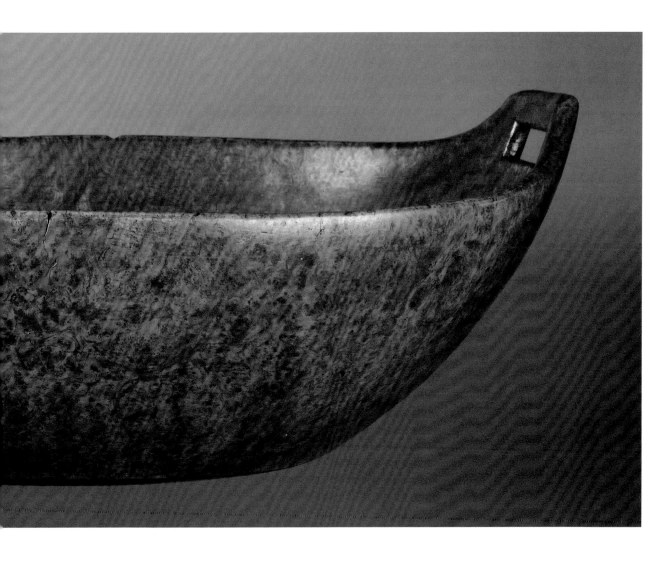

Desk-and-bookcase

about 1775

Boston or Salem, Massachusetts
Mahogany, eastern white pine, and brass
100 × 40 × 23½ in.
2016.11.8

Popular throughout coastal New England, the highly practical desk-and-bookcase was among the most monumental forms of furniture in 18th-century America. Listed in the inventories of affluent attorneys, ministers, merchants, and sea captains, as well as scholars and artisans, these impressive objects served as tangible expressions of the owner's wealth and standing in the community. They were made most frequently for men, who needed to write and file papers. With lockable drawers and concealed interior storage compartments, such a desk was the forerunner to the home safe and filing cabinet.

Block-front furniture such as this was popular in Boston, Salem, Newport, and parts of Connecticut from approximately 1740 to 1780. By using thicker wood and deeper carving on the fronts of the case drawers and dividers, cabinetmakers created an undulating, alternately convex and concave, "blocked" façade.

With its sweeping verticality, its swan-neck pediment culminating in intricately carved rosettes, its arched panel doors made of richly figured mahogany, and its finely carved claw-and-ball feet, this desk-and-bookcase is an extraordinary example of Boston-area cabinetmaking in the latter half of the 18th century. The desk has several inscriptions and marks related to the history of its ownership. "T. Greenleaf 1804" and "Harvard College" are inscribed on the right and left sides respectively of the left loper, or lid support. "Francis James Child Oct. 1847" (pencil) and "Susan Wesson" (ink) are inscribed on the side of an interior drawer.

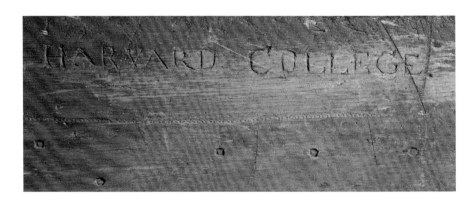

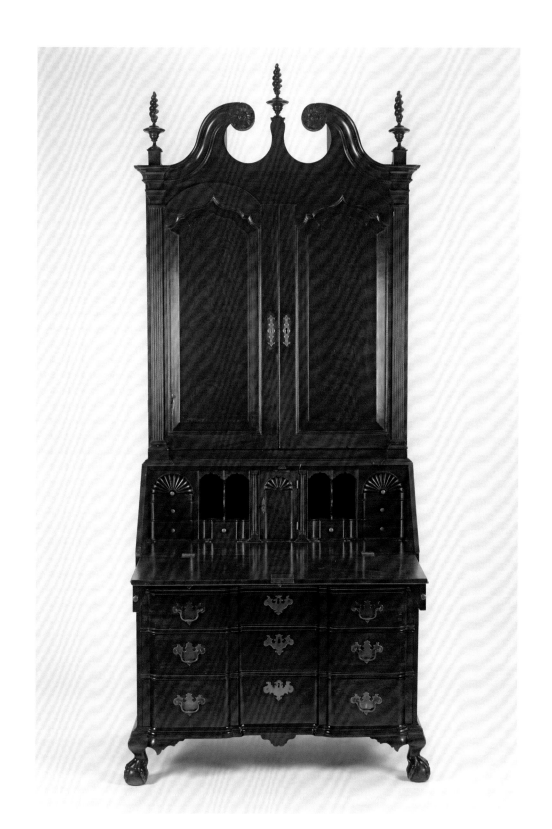

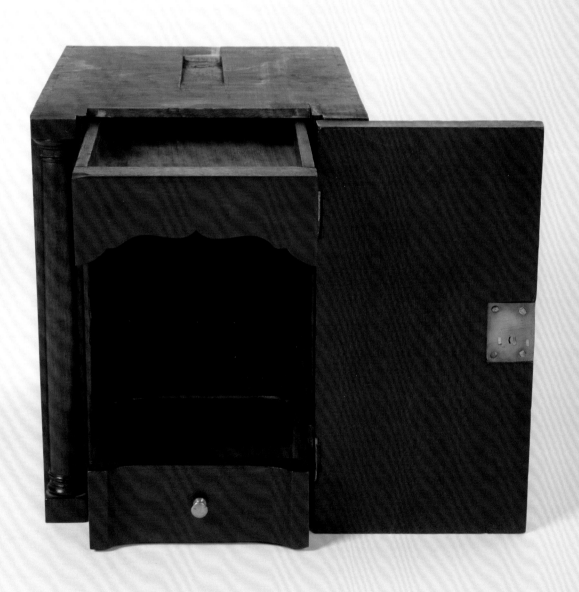

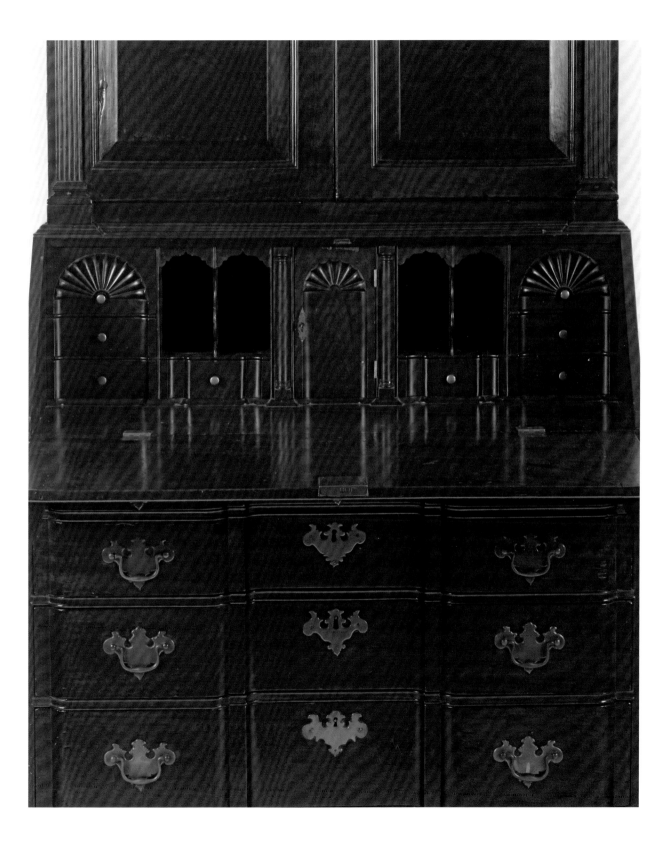

Ives family coat of arms

1763

Rebecca Ives Gilman (1746–1823)
Beverly, Massachusetts
Silk, gold, and silver thread on black silk
17 × 16 in.
2016.11.11

Throughout the 18th century and well into the 19th, girls between the ages of 8 and 18 were taught fancy needleworking skills as part of their preparation for marriage and later life. Embroidered coats of arms such as this were produced in female academies in the Boston area as symbols of social status and family pride.

This coat of arms with the inscription "By the name of Ives 1763" was one of two stitched by Rebecca Ives in 1763 when she was 17 years old. Rebecca was the only daughter of Captain Benjamin Ives and Elizabeth Hale Ives. In the year she stitched this piece, Rebecca married Joseph Gilman in Salem, Massachusetts. After their marriage, they moved to the Gilman family home in Exeter, New Hampshire, where Joseph became a prominent businessman and community leader.

In 1788 the family moved to Marietta, Ohio. Over the next several years, Joseph Gilman was appointed to public offices of increasing responsibility and influence. In 1790 George Washington named him Judge of the Northwest Territory. After her husband's death in 1806, Rebecca remained in Ohio until about 1812, when she moved to Philadelphia to be near her son, Benjamin.

Rebecca maintained an especially close relationship with her older brother Robert Hale Ives. She most likely stitched the first coat of arms as a gift for her beloved brother and the other for herself. In dating hers 1763, the year she took the name of Gilman, she may have wished to acknowledge her own family lineage "by the name of Ives."

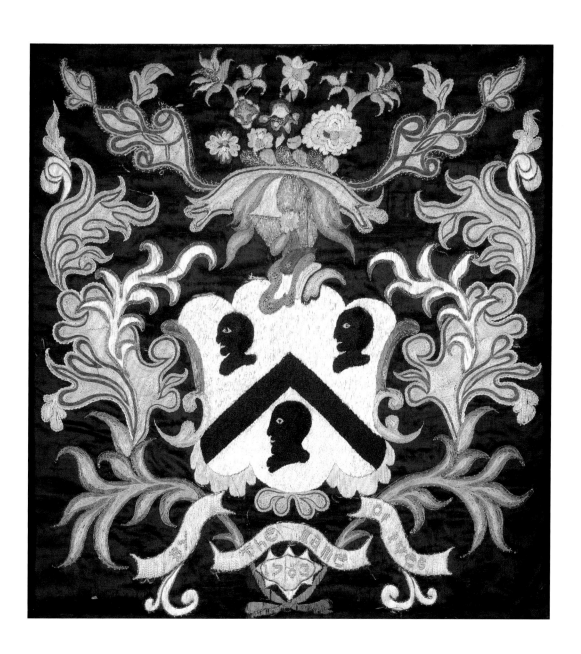

Powder horn

1766

———

New England
Cow horn and pigment
6½ × 14 × 5 in.
2017.5.76

———

Powder horns were of critical importance to soldiers in the mid-18th century. Prior to the development of wooden cartridge boxes in the late 1770s, they provided a safe, dry place to store the gunpowder used in rifles. Usually made from cow horn, they were often inscribed with the owner's name, the date, and highly inventive designs. This horn was inscribed by its maker: "Obediah Hall his horn made at Concord May the 12th 1766."

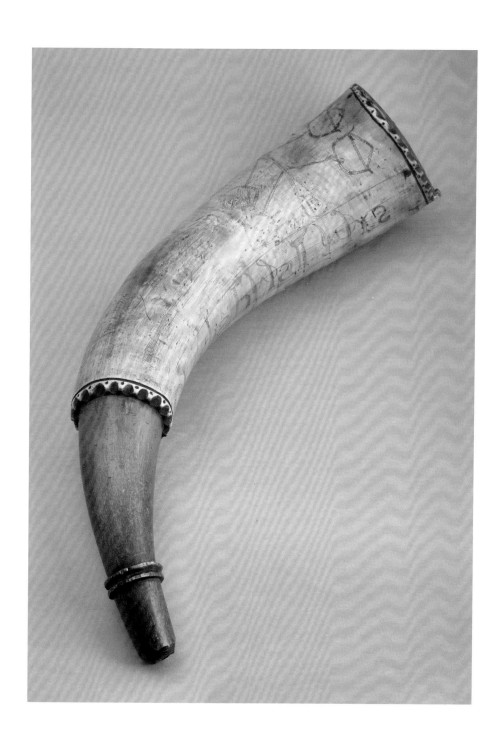

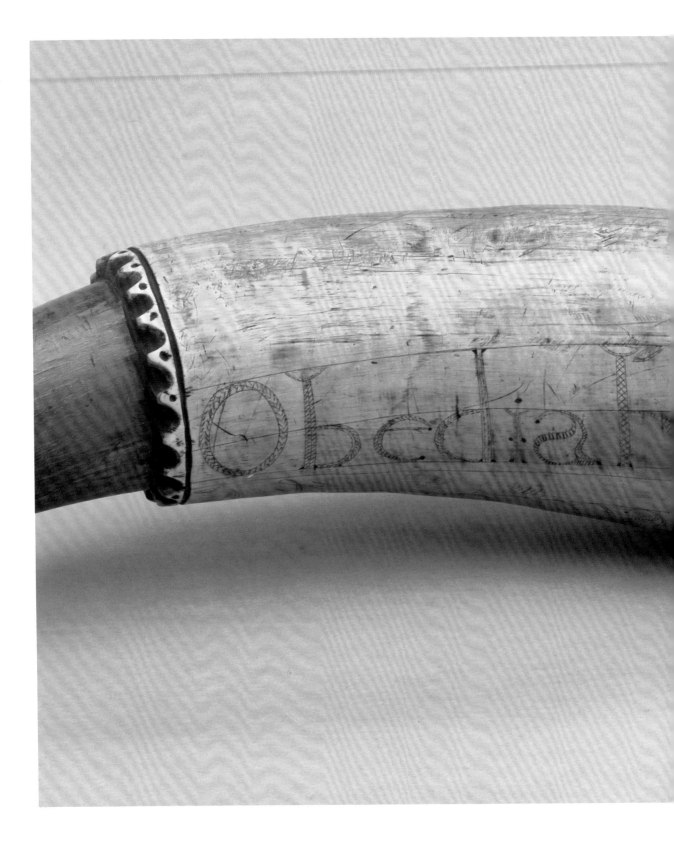

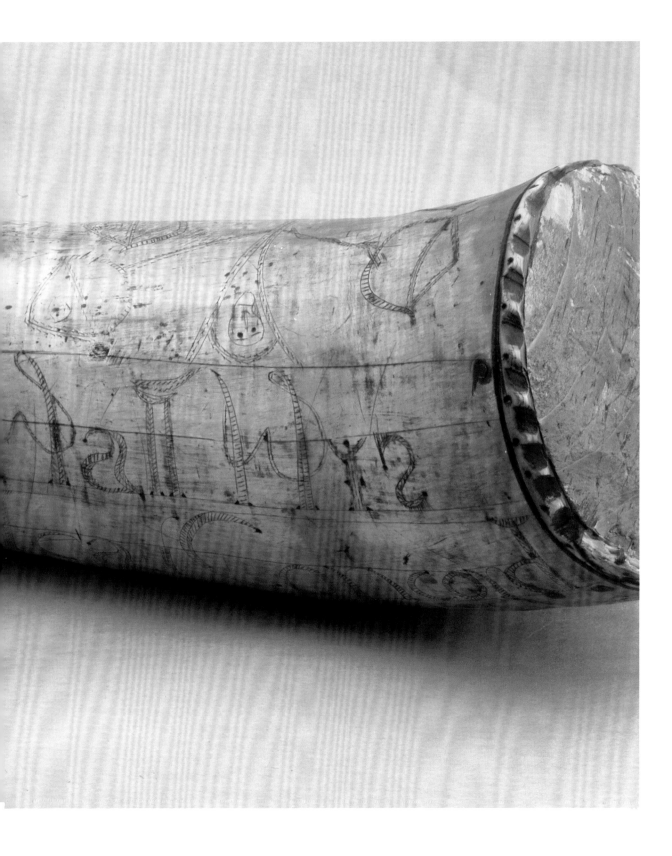

Tall case clock

about 1780

Jonathan Mulliken II (1746–1782)
Newburyport, Massachusetts
Mahogany, pine, glass, and brass
85 × 21¾ × 11 in.
2016.11.10

Known today as "grandfather clocks" or "grandfather's clocks," tall case clocks in the 18th century were prominently displayed in the best parlor or entry hall of the home, where they could be admired by visitors, a symbol of a family's wealth and standing within the community. The brass components for most American-made clocks were imported from England or northern Europe and assembled in America by skilled artisans. Cases for these clocks were usually made by craftsmen with different sets of tools and skills.

This elegant example was made by the Newburyport, Massachusetts–based clockmaker Jonathan Mulliken II. Born in Bradford, Massachusetts, into a family of clockmakers, he most likely apprenticed with his uncle Nathaniel Mulliken, a prominent engraver and clockmaker.

Jonathan Mulliken's name and "Newbury Port," the town where his shop was located between 1772 and 1782, are engraved in a brass signature plate above the dial. However, it is not known who made the clock's handsome mahogany case.

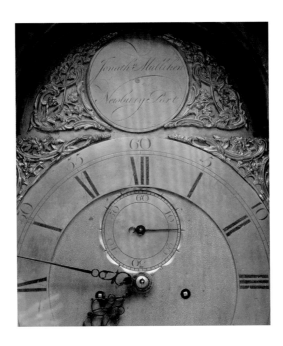

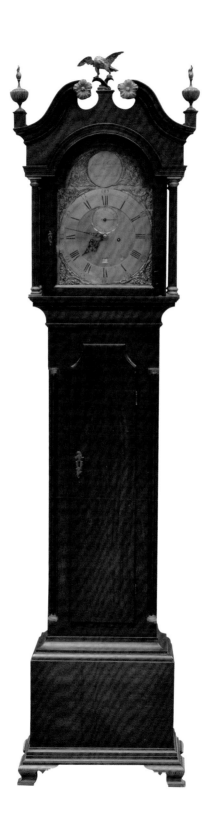

Chair

1760–80

—

New York
Mahogany and silk
38 × 22½ × 22 in.
2016.11.12

—

Typical of furniture produced in New York in the last quarter of the 18th century, this elegant side chair in the Rococo style features an elaborately carved, serpentine crest rail and knees; a splat with interlacing scrolls and a diamond pattern; large square claw-and-ball feet; and elaborate carving (a gadroon pattern) below the front seat rail. A Roman numeral VII is carved on the rear seat rail, indicating that this chair was once part of a large set.

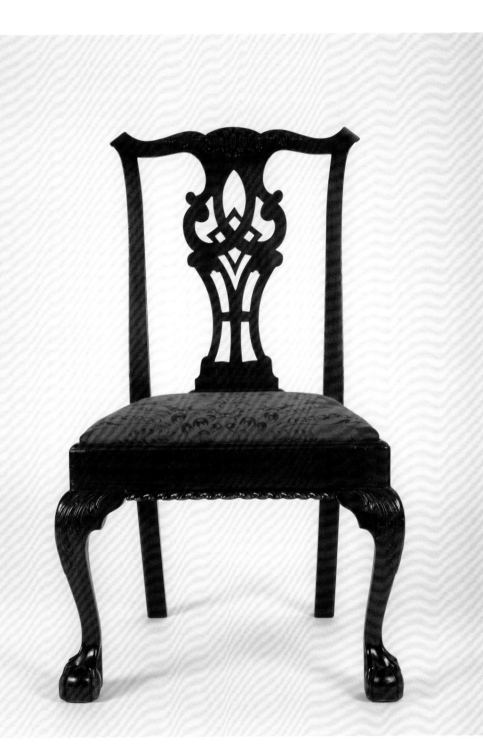

Portrait of Margaret Chew Bordley

about 1752

John Wollaston (active 1742–75)
Annapolis, Maryland
Oil on canvas
30½ × 24½ in.
2016.11.7

Margaret Chew (1735–1773), a member of a prominent Philadelphia family, married John Beale Bordley (1727–1804), an attorney and Maryland planter, in 1750. Shortly after their marriage, the couple moved to Annapolis and then to the rural community of Joppa, Maryland. In Joppa, and later at a plantation on Wye Island off Maryland's eastern shore, Bordley conducted agricultural experiments, including crop rotation, that revolutionized planting practices in America. Margaret raised their four children and died in 1773.

English artist John Wollaston moved to New York about 1749 and painted portraits of the city's most notable leaders through 1752. He later traveled to Philadelphia, Annapolis, Virginia, and Charleston, where he painted over two hundred portraits before returning to England in 1767.

Here, the heavy-lidded, almond-shaped eyes and interest in the play of light on satin, silk, and lace are characteristic of Wollaston's work of the period. This quarter-length portrait was most likely painted in Annapolis.

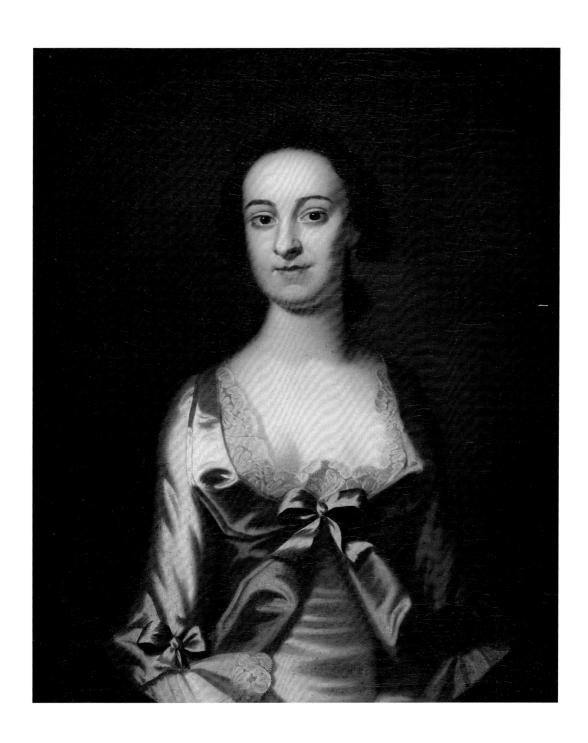

Portrait of a Woman

1780–90

————

Artist unknown
America
Oil on canvas
23¾ × 19 in.
2017.5.29

————

While neither the artist nor the subject of this work is known, the fine rendering of the facial features and the adept treatment of the fabrics reflect an artist with considerable training and talent. According to the donors, the subject of this portrait lived in New York City or eastern Long Island. Based on the style of the kerchief and the cap with lace lappets—long pieces attached to the cap to secure it under the chin—this portrait was painted in the 1780s.

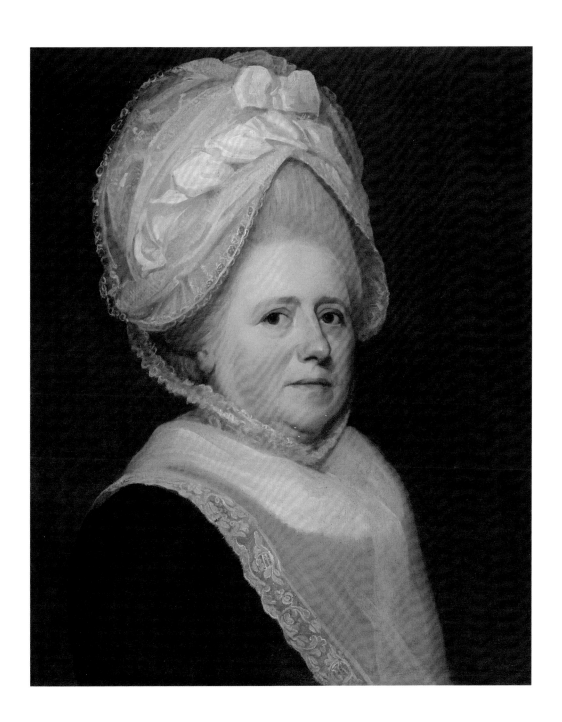

Chest of drawers

1800–1810

———

Eastern New Hampshire
Mahogany, eastern white pine, and brass
34½ × 38¼ × 23½ in.
2016.11.13

———

In the 18th century, clothing and other valuable textiles were often folded and stored in chests of drawers. The locks commonly seen on the drawers of a chest such as this attest to the valuable nature of its contents.

This mahogany and pine chest is part of a small group of related pieces produced in eastern New Hampshire about 1800. Though its curving bow-front form suggests the regional cabinetmaker's awareness of design innovations in the Neoclassical period, its claw-and-ball feet harken back to an earlier Rococo style. The wood panel above the top drawer slides out to become a work surface, useful for folding and straightening clothing and other fabrics before placing them in the chest.

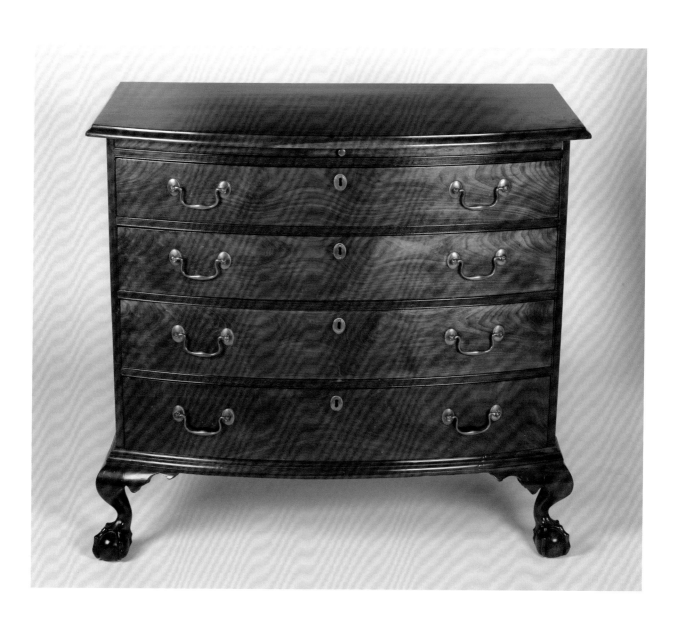

Looking glass

1810–15

———

America or England
Giltwood, silvered glass, and *verre églomisé*
49¼ × 30¾ × 5½ in.
2016.11.14

———

Looking glasses often feature neoclassical architectural motifs such as pilasters, capitals, acanthus leaves, dancing female figures, and projecting ornamental cornices. On this piece, the eagle, insignia, and flag—painted on the reverse side of the glass panel in a *verre églomisé* technique—suggest American origins, but similar looking glasses were produced in England and France for export to the American market.

Frames for these looking glasses were typically made of pine, with the sculptural ornamentation either carved from soft wood or made in molds from composite materials then applied, gessoed, and gilded. The fine, crisp detailing of the composite capitals, the attenuated proportions of the columns, and the relatively small scale of the decorative balls beneath the breakfront cornice suggest a date of about 1810–15 for this looking glass.

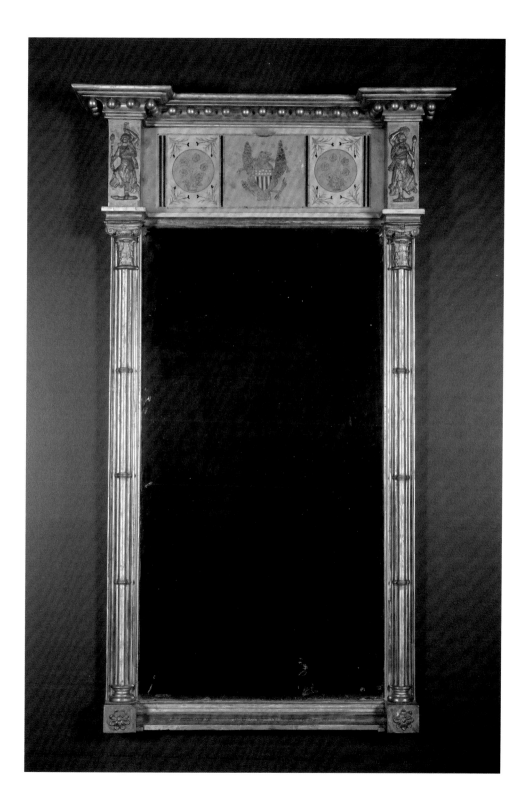

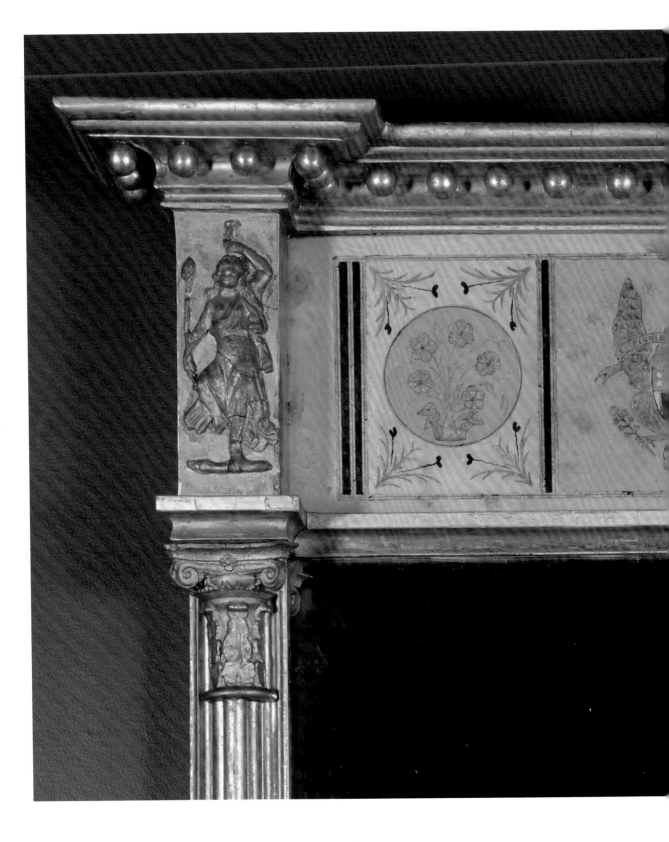

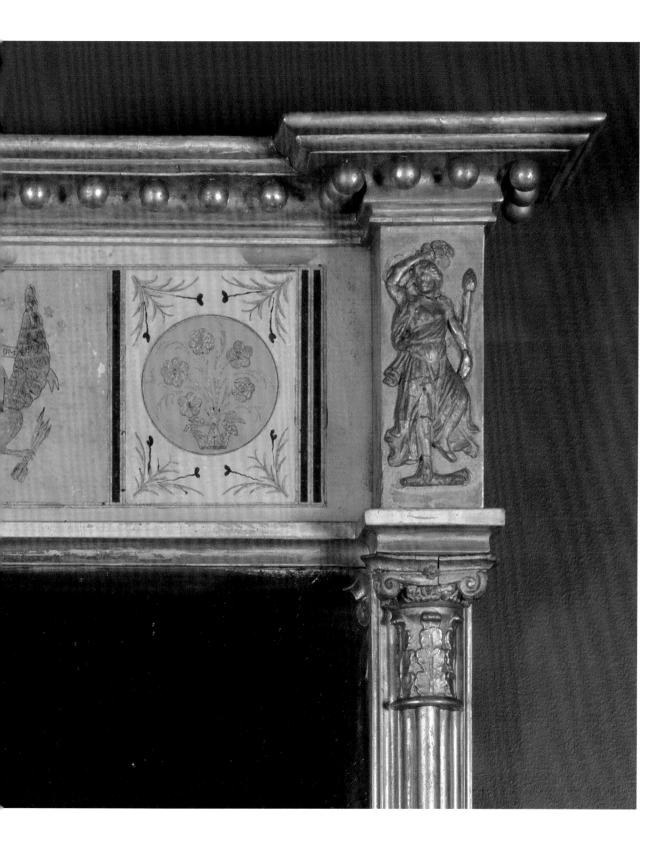

Lolling chair

about 1800

———

Massachusetts
Mahogany and silk
43½ × 27 × 24 in.
2017.5.3

———

The term "lolling chair"—later known as a "Martha Washington chair"—was used in the late 18th and early 19th centuries to describe a comfortable, fabric-covered chair with a tall back and open, un-upholstered arms. According to probate records of the period, these chairs were used in both formal parlors and bedchambers and were often grouped in pairs.

A woman might have sat in a chair such as this—a worktable by her side—as she read or did her needlework. This example, with continuous molded contours on the arms and elegantly tapered legs, was probably made in the first decade of the 19th century.

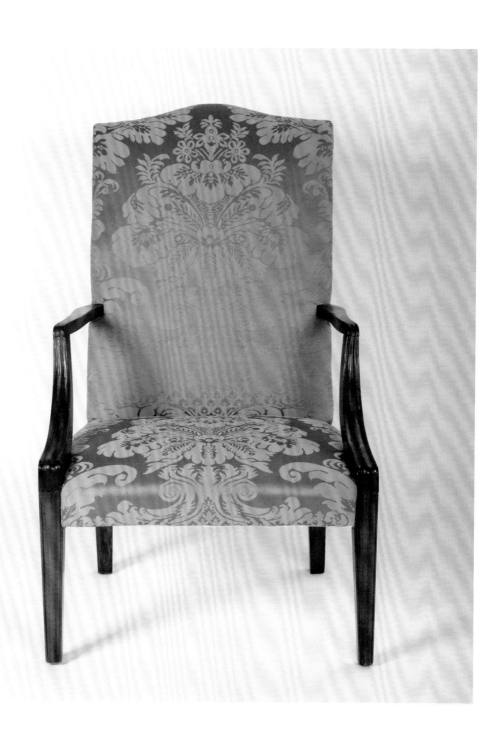

Sampler

1796

———

Anne "Nancy" Moulton (born 1786; death
date unknown)
Newburyport, Massachusetts
Silk on linen
23¼ × 20⅜ in.
2017.5.45

———

This unusually large sampler with a meandering
floral border depicts a pastoral landscape in which
wild and domesticated animals—cows, sheep,
dogs, and birds—peacefully coexist. It is related to
a group of pictorial compositions known today as
"Shady Bower" samplers. The heart and trefoil
bands, as well as the checkered sawtooth border,
appear frequently in samplers produced around
Newburyport, Massachusetts. Undoubtedly a
teacher in the area created the designs, which
were used in samplers by several of her students.
Needlework scholar Tricia Wilson Nguyen has
identified Betty (Betsy) Bradstreet (1738–1815) of
Newburyport as possibly being that teacher.

Born in Newburyport on October 19, 1786, Anne
Moulton—also known as Nancy Moulton—was
one of 12 children of the American silversmith
Joseph Moulton (1744–1816) and his wife Abigail
Noyes Moulton (1744–1818).

Moulton made this sampler when she was 10.
However, she never fully completed it. For some
unknown reason, she neglected to stitch several
of the floral designs that appear in the lower quar-
ter of the sampler. Her omission provides us with
insight into the needleworker's process and the
relationship between the teacher, who most likely
drew the design, and her student.

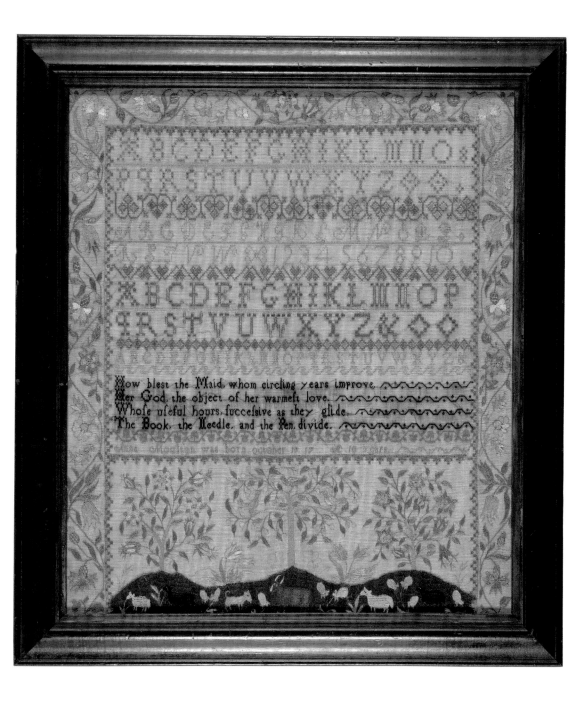

ABCDEFGWIXEMIIO:
PSRSTUVWXYZ

ABCDEFGHIKLMMOP
QRSTVUWXYZ&

How blest the Maid, whom circling years improve.
Her God, the object of her warmest love.
Whose useful hours, successive as they glide,
The Book, the Needle, and the Pen, divide.

Candlestand

about 1800

———

New England
Mahogany
29 × 20½ × 17¼ in.
2017.5.4

———

With its spare, octagonal top, vase-shaped pedestal, and long, curving legs ending in spade feet, this candlestand is typical of furniture produced in the Neoclassical style, which was fashionable in America in the late 18th and early 19th centuries. The table would have held a candle and been placed beside a chair to provide light for reading, sewing, or writing.

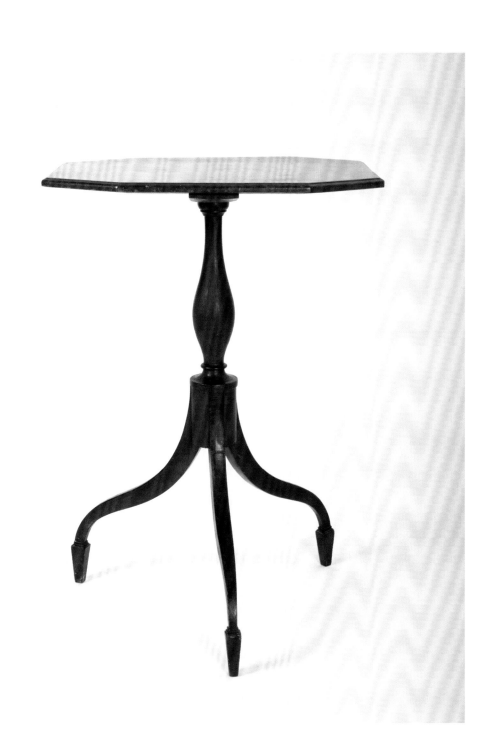

Girandole mirror

1810–25

America or England
Giltwood, metal, crystal, and silvered glass
43 × 30 × 11 in.
2016.11.15

The Cabinet Dictionary of 1803, written by the influential British designer Thomas Sheraton, defines a mirror as "a circular convex glass in a gilt frame, silvered on the concave side, by which the reflection of the rays of light are produced." This form was popular in England and France beginning around 1800 and in America from 1805 to the 1840s. Less practical than the standard, flat "looking glass," this type of round convex mirror reflected an entire room or vista in a visually interesting though distorted perspective. The so-called "girandole mirror" also featured sconces for candles, whose light would be reflected and amplified by the mirror's convex surface.

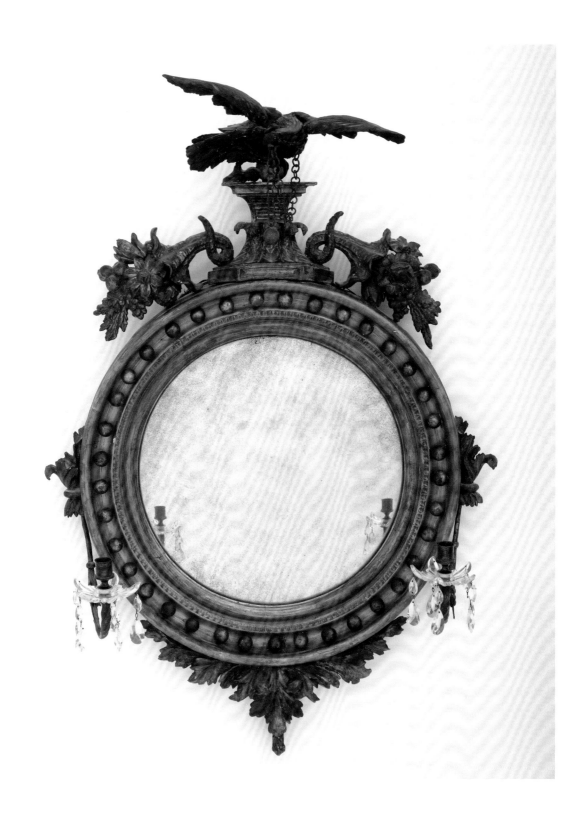

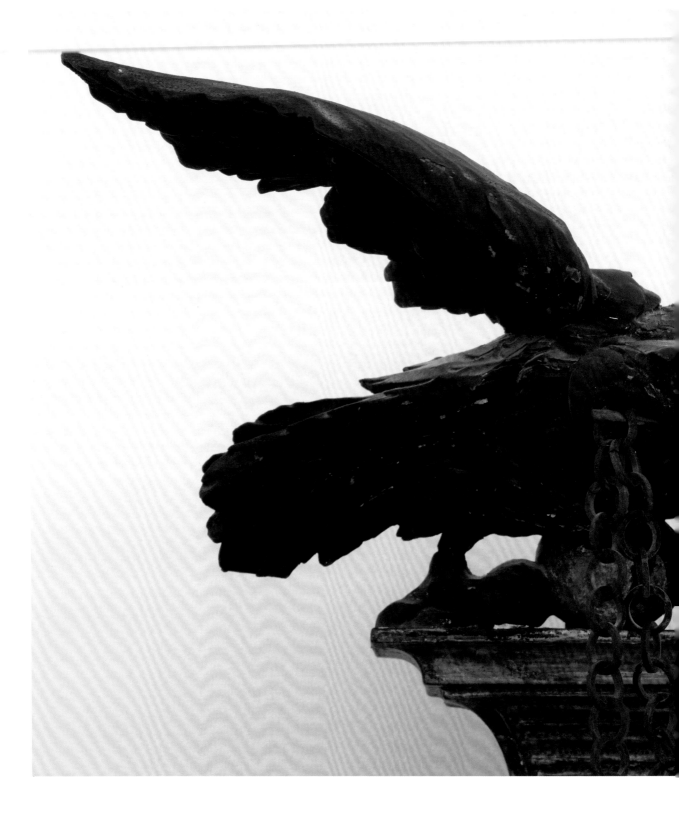

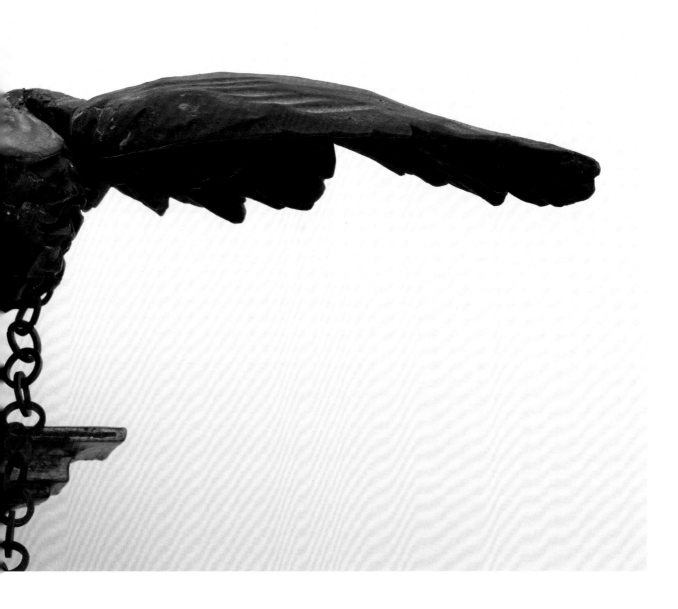

Eagle

about 1815

New York
White pine
19 × 48 × 16 in.
2017.5.23

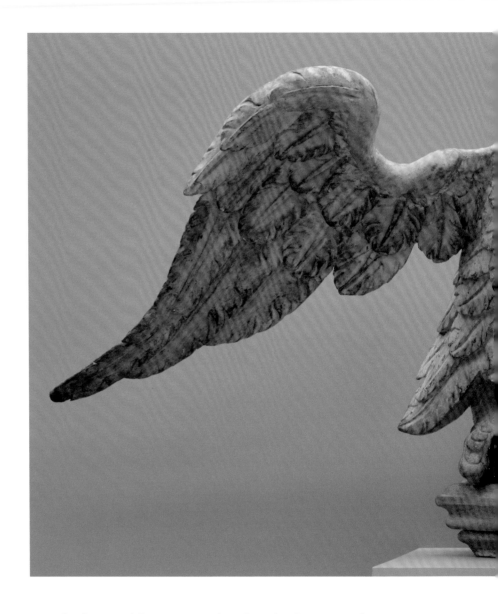

Carved architectural decorations, such as the rather ferocious eagles
seen here and on the following pages, are among the earliest exam-
ples of surviving sculpture in America. With their gnarled talons
and expertly defined feathers, necks, and heads, these two eagles
are fine specimens of wood-carving traditions in early America. The
larger one with outstretched wings poised for flight comes from a
house built in 1815 in Cape Vincent, New York.

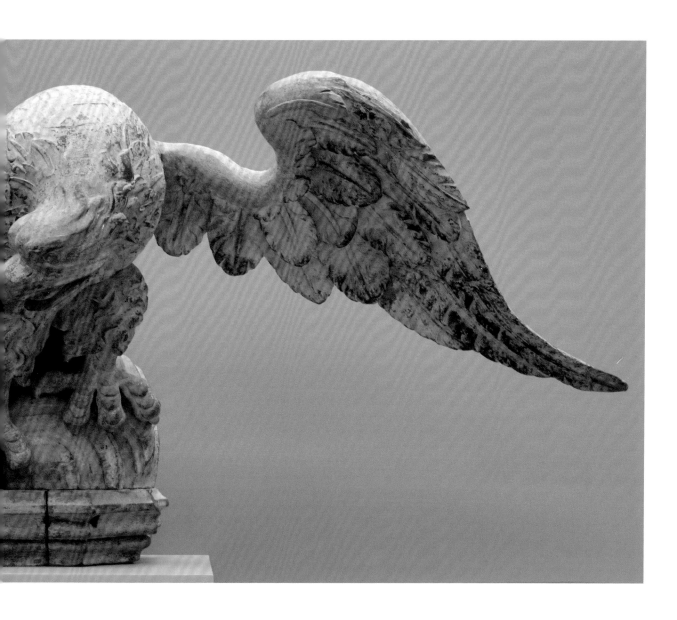

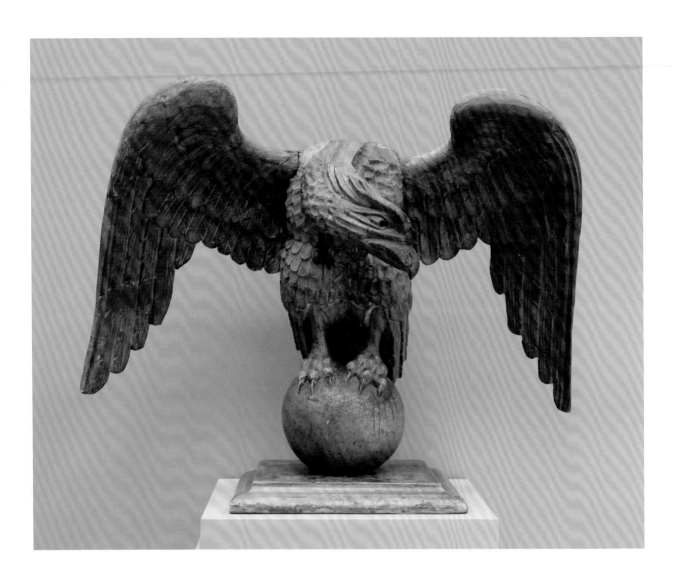

Eagle

about 1800

America
Red pine
21 × 24 × 12 in.
2017.5.69

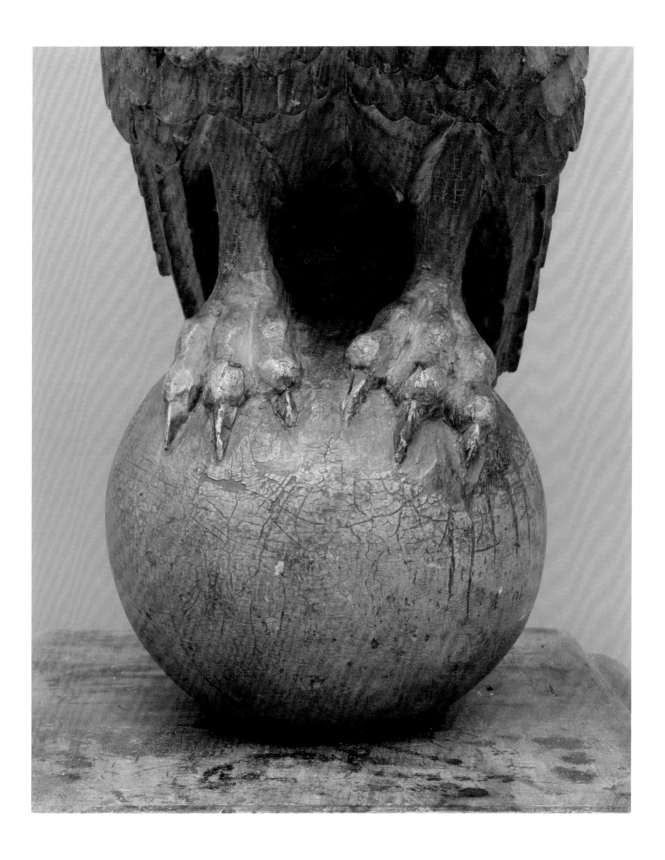

Banjo clock

about 1805

Simon Willard (1753–1848)
Roxbury, Massachusetts
Mahogany, glass, reverse-painted glass
panels, and brass
29½ × 9¾ × 4 in.
2016.11.16

Wall-mounted timepieces such as this "banjo" clock became very popular in America in the first quarter of the 19th century. They received their name because of their distinctive shape and their resemblance to the musical instrument. Developed by Simon Willard and patented in 1802, these clocks were simple in design, standardized, and efficient to produce, making them affordable for an ever-expanding middle-class market.

Simon Willard was part of a family of clockmakers who were active in the Boston area in the late 18th and early 19th centuries. One of four brothers, all clockmakers, Simon learned his trade from his older brother Benjamin. Simon was ultimately the most inventive and successful of the four siblings.

The geometric forms comprising the body of this clock reflect the neoclassical taste in America in the first decades of the 19th century. The decorative finial in the shape of an eagle embodies the widespread patriotism and national pride following the American Revolution.

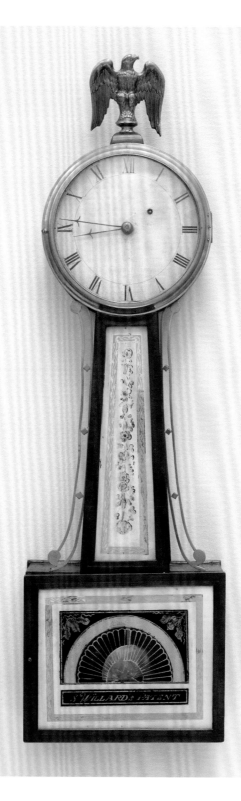

Portrait of a Sea Captain

about 1810

William Jennys (1774–1859)
America
Oil on canvas
21 × 16 in.
2017.5.18

Though his birthplace is uncertain, the itinerant portraitist William Jennys is known to have lived and worked in southeastern Connecticut in the early 1790s. He placed an advertisement in a newspaper in Norwich, Connecticut, in 1793, and his earliest-known paintings date to the mid-1790s, when he was working in New Milford. In 1797 and 1798, he was listed in the city directory in New York, and by 1807 he had made his way to Newburyport, Massachusetts, a coastal town north of Boston.

This quarter-length portrait of a handsome young sea captain is typical of the work that Jennys did in the first decade of the 19th century. With his stylish attire and his direct gaze, this gentleman is clearly a man of the world, as he holds a spyglass—a symbol of his profession and his worldly status.

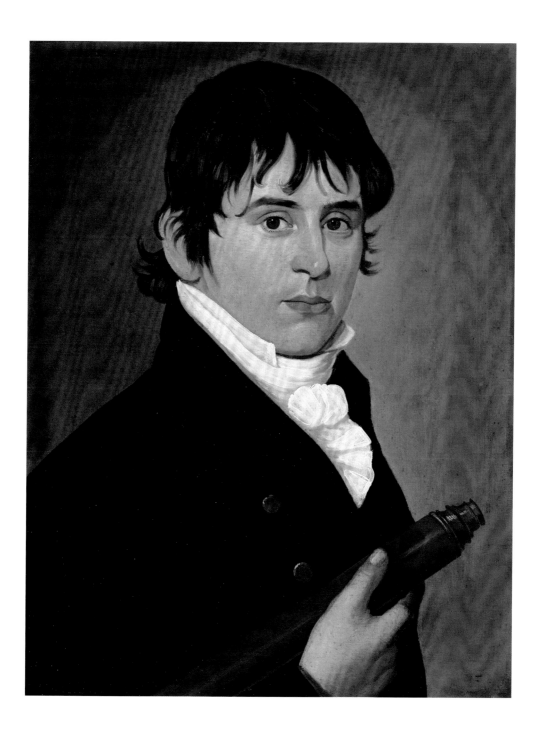

Seascape

1805–15

Thomas Buttersworth, Sr. (1766–1841)
England
Oil on canvas
18⅛ × 24 in.
2016.11.17

A painter of detailed ship portraits and dramatic sea battles, the British artist Thomas Buttersworth was born on the Isle of Wight in 1766 and baptized there in 1768. He enlisted in the British Royal Navy in 1795 and served for five years. Little is known about his training as an artist. However, by 1810 he was sufficiently advanced in his skills to be named the official marine painter to the East India Company. He exhibited his work at the British Royal Academy between 1813 and 1827.

Buttersworth's seascapes were very popular in America in the first half of the 19th century and were often reproduced as prints. Their appeal is not surprising in a period when travel by sea provided the principal link between the United States, Europe, and the rest of the world. Battles over territory, trade routes, and international dominance were frequently fought at sea.

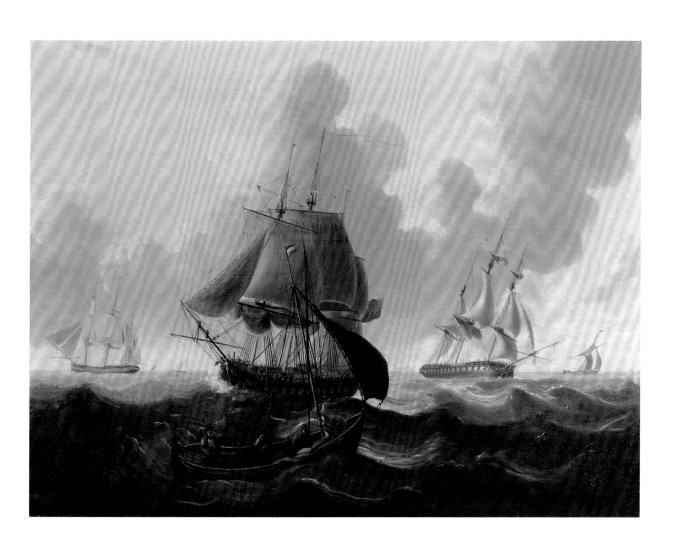

Sideboard

about 1810

Possibly New Hampshire
Mahogany with mahogany, rosewood,
and dyed satinwood veneers, and brass
33¾ × 41¾ × 22½ in.
2017.5.9

In the late 18th century, as dining customs in America became increasingly formal and rooms began to assume more specific purposes, a wide variety of furniture forms developed to meet the household's serving, dining, and storage needs. During this period, sideboards became a common feature of American dining rooms. Containing a variety of drawers and cupboards, they held everything from tablecloths and linens to plates, glassware, and silver. Placed against a wall, sometimes in a recessed niche or between windows, they were typically quite large.

This handsome sideboard, made in the curved bowfront style that was popular during the late 18th-century Neoclassical period, is unusually small. Its two long drawers, faced in a rich burl veneer, are lockable—a testament to the valuable nature of the contents. The rounded "ovolo" corners on the top, the ring turning on the colonnettes, and the delicate swell to the four reeded legs suggest New Hampshire origins.

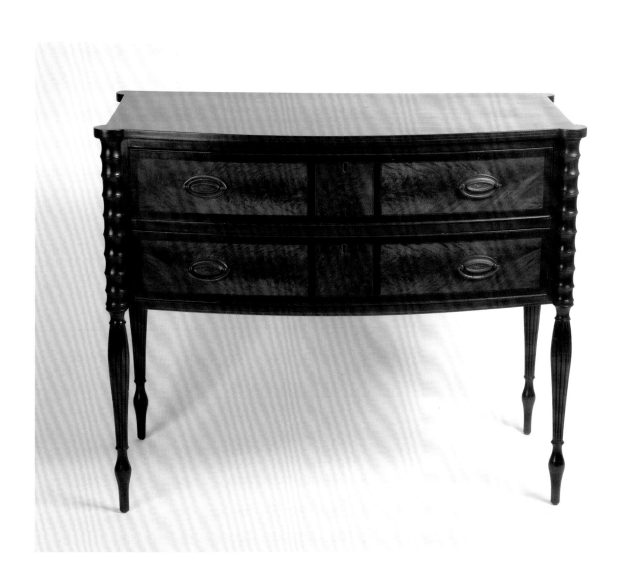

Shelf clock

1816–25

Eli Terry (1772–1852)
Plymouth, Connecticut
Mahogany, yellow poplar, cherry, white
oak, bone, brass, glass, and *verre églomisé*
32 × 18 × 5¼ in.
2017.5.12

This type of clock—popularly known as a "pillar and scroll clock" because of its dual columns and its dramatically curved pediment topped by brass, urn-shaped finials—was patented by the Connecticut-based clockmaker Eli Terry in 1816. Prized for their accuracy and affordability, Terry's clocks came with a warranty that stated: "The public may be assured that this kind of clock will run as long without repairs, and be as durable and accurate for keeping time, as any kind of clock whatever." Less expensive than tall case clocks, shelf clocks were very popular in America in the first half of the 19th century. In this example, an image of George Washington's home, Mount Vernon, is reverse-painted on the lower panel of the glass door.

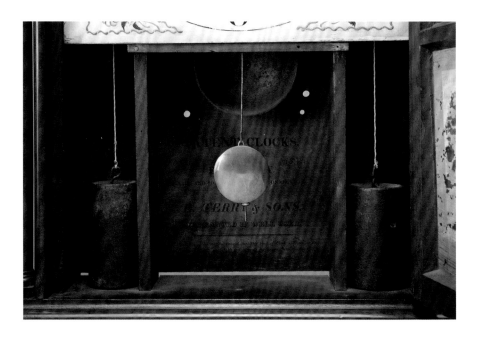

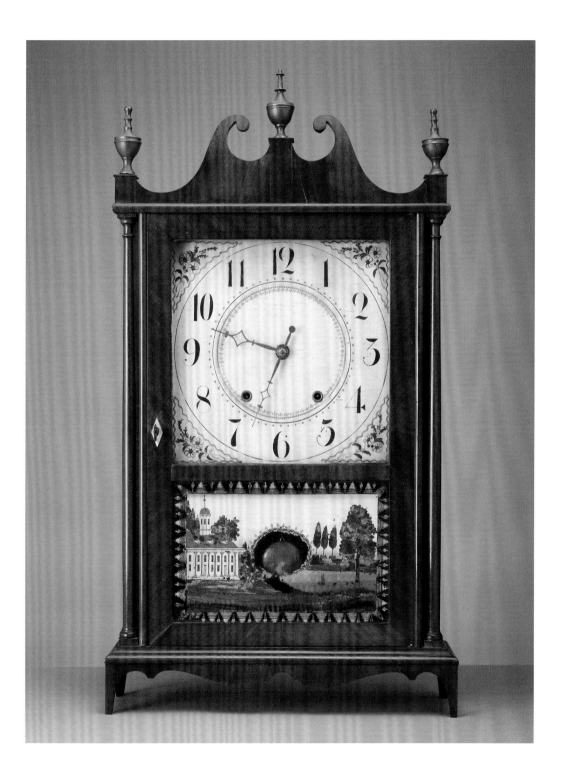

Sampler
1804

Mary Graham (born 1791; death date
unknown)
Philadelphia
Silk on linen
20 × 25 in.
2017.5.44

According to the inscription, Mary Graham
stitched this sampler in 1804, when she was 13.
This expansive pastoral landscape, populated by
sheep, dogs, rabbits, an eagle, and birds flying
overhead, seems the perfect embodiment of the
lines from Joseph Addison's 1712 hymn: "The Lord
my pasture shall prepare, and feed me with a shep-
herd's care."

The asymmetrical placement of a house in a
verdant landscape, delicately worked willow trees,
rail-and-picket fence, and slender, high-waisted
Empire-style clothing are characteristic of sam-
plers produced in Philadelphia in the first decades
of the 19th century. In her publication *Girlhood
Embroidery: American Samplers and Pictorial
Needlework, 1650–1850*, scholar Betty Ring refers
to this landscape type as the "house and garden
form" and notes that it first appeared in Philadel-
phia about 1798 and continued until 1834.

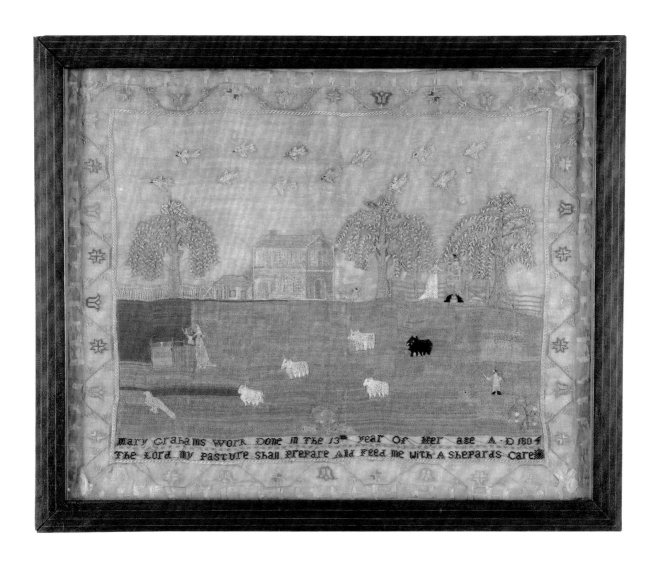

Memorial to Captain John Allen

1811

Elizabeth Robinson Allen (1792–1816)
Barre, Massachusetts
Silk and watercolor on paper
13 × 14½ in.
2017.5.41

Memorials—contemplative tributes to specific deceased relatives and friends—became widely popular in America in the first decades of the 19th century. These compositions often combine intricate needlework in the trees and landscape with watercolor painting, which permits greater detail in the rendering of the grieving figure's face, hands, and costume.

Elizabeth Allen was born in 1792, the daughter of Captain John Allen (1764–1811) and Hannah Robinson Allen (born in 1767). Her parents' families lived in Barre, Massachusetts, a rural community west of Worcester in the central part of the state. Her parents married in Barre on December 18, 1788. One of seven children, Elizabeth stitched this tender tribute to her deceased father when she was 19. She died just five years later, in 1816, at age 24.

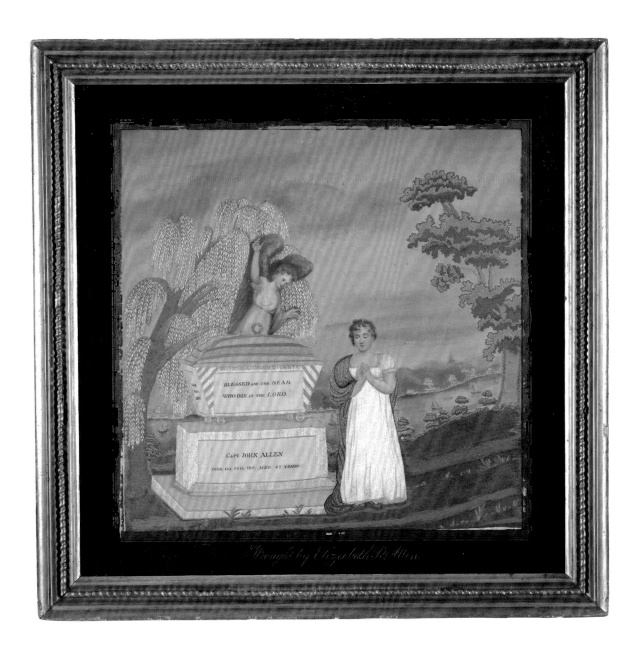

BLESSED are the DEAD,
WHO DIE in the LORD.

Capt. JOHN ALLEN
DIED Oct. 29th, 1815. AGED 47 YEARS.

Wrought by Elizabeth B. Allen.

Family Record

1820

———

Elizabeth Stone (1808–1879)
Middlesex County, Massachusetts
Silk on linen
20 × 14 in.
2017.5.39

———

This sampler was stitched by Elizabeth Stone in 1820, when she was 12 years old. We know from the sampler that Elizabeth was the eldest child of William Stone (1781–1856) and Elizabeth Coolidge Stone (1784–1874), who were married in Watertown, Massachusetts, on April 9, 1807. Watertown is in Middlesex County, just west of Boston. Eight years after completing this family tree, Elizabeth married Seriah Stevens (1793–1855). They settled in Boston and raised a family of three children.

This "tree of life" or "apple tree" sampler, with its three-sided flower and leaf border and its use of yellow fruit for the girls and white fruit for the boys, is typical of needlework produced in Middlesex County in the first quarter of the 19th century. The linked or overlapping heart motif at the base of the tree is often seen in work produced in this region.

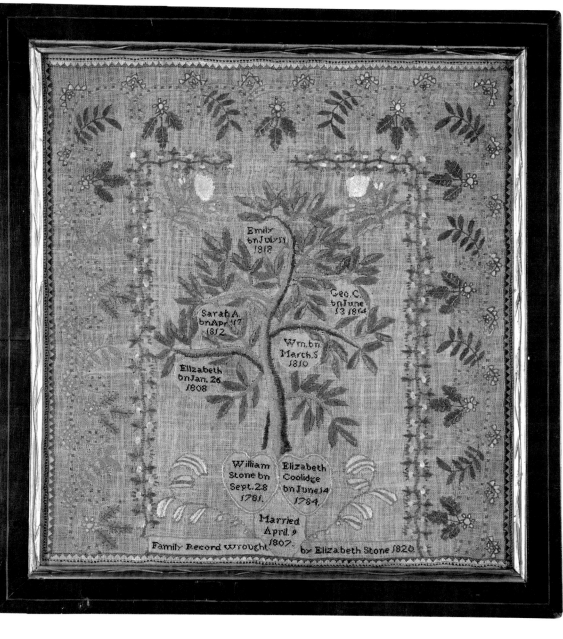

Chest of drawers

about 1810

———

Possibly New Hampshire
Tiger maple, mahogany, pine, bone, and brass
45 × 46½ × 20 in.
2017.5.10

———

This tall chest of drawers is made of tiger maple with mahogany and bone inlay. It has rounded "ovolo" corners that cap three-quarter, ring-turned colonnettes and reeded columns. The large drawers on either side of the smaller stacked pair are unusual and may have been used to store hats or other large items of clothing. All locks on the chest are decorated with bone in a vivid diamond pattern, and the drawer pulls are sheathed in brass with a portrait bust of Benjamin Franklin.

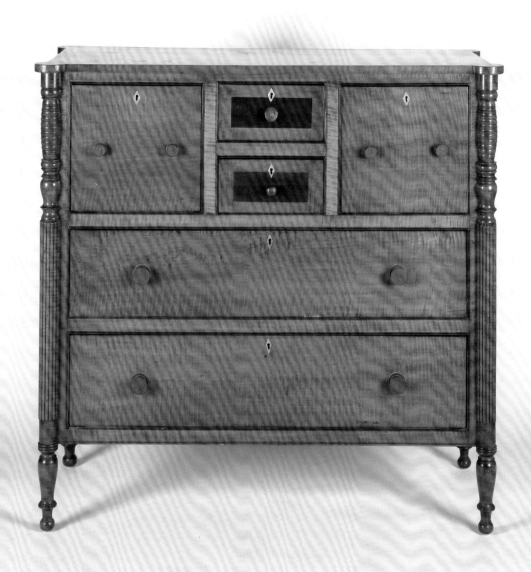

ABC dish

1800–1825

America
Redware
1½ × 9 in.
2017.5.85

Lead-glazed earthenware, **known today as "red-ware,"** was produced in America from the early 1600s well into the 19th century. Pressed into molds rather than thrown on a potter's wheel, redware vessels were made from porous clay. Fired at relatively low temperatures, they required glazing to render them watertight. Decorative designs or inscriptions such as those seen on these plates were applied in yellow slip, a thin watery clay, prior to firing.

DE dish

1800–1825

America
Redware
1½ × 8½ in.
2017.5.86

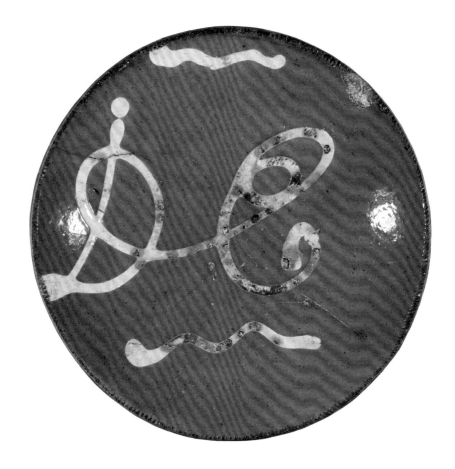

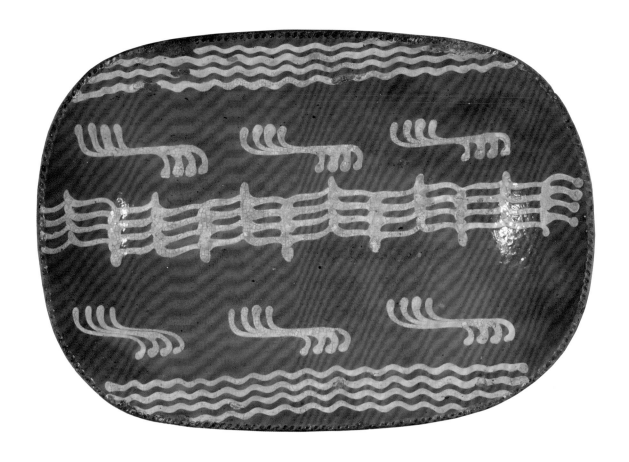

Loaf dish

1800–1825

America
Redware
2 × 12½ × 18 in.
2017.5.87

Mince pie dish

1800–1825

America
Redware
1 × 10⅛ in.
2017.5.88

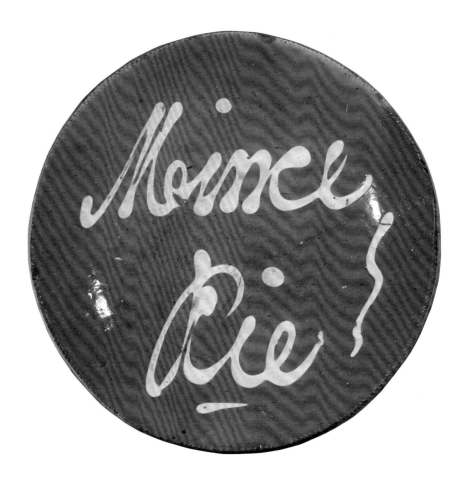

Platter

1830–50

England
Spatterware
1⅝ × 15¾ × 12⅛ in.
2017.5.34

Produced in potteries throughout England in the first half of the 19th century, spatterware—earthenware with brightly colored speckled decoration—was intended primarily for the American market, where its vivid colors and bold patterns were greatly admired. Decorated by tapping a brush or blowing powdered pigments onto the surface of a vessel through a straw prior to firing, spatterware was produced in a broad range of patterns and a wide variety of subjects. Hand-painted images of flowers, fruits, and birds often appear, with peafowl among the most popular designs imported into the United States.

Spatterware's bold patterns and striking color combinations would have added a distinct visual liveliness to the 19th-century American home. It was particularly popular in Pennsylvania, where the German and Northern European taste for bright color and bold patterns persisted well into the 19th century.

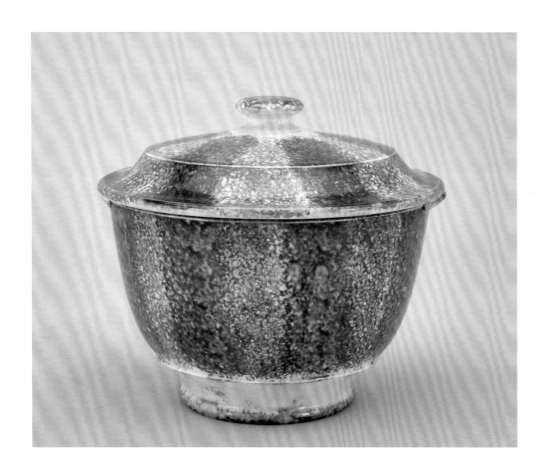

Covered bowl

1830–50

England
Spatterware
4 × 5¼ in.
2017.5.38

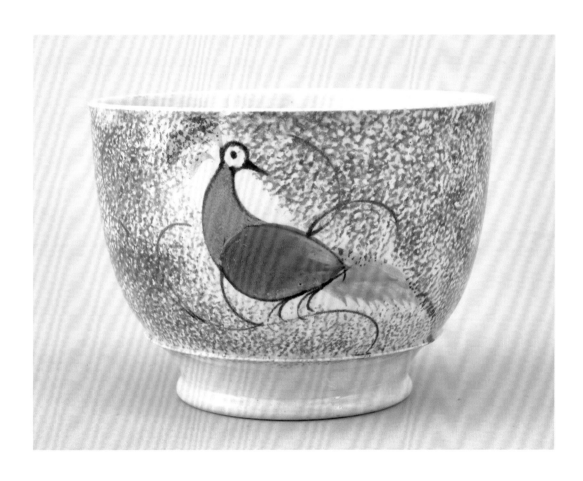

Bowl with peafowl decoration

1830–50

England
Spatterware
3⅛ × 4¼ in.
2017.5.37

Sampler

1840

———

Isabel Arthur (born 1830; death date unknown)
Bethel Park, Pennsylvania
Wool on linen
16½ × 24 in.
2017.5.46

———

This sampler was stitched in 1840 by Isabel Arthur, daughter of William and Jane Arthur. In addition to acknowledging her mother and father, the young needleworker stitched the name of her teacher, Mary Tidball, in a prominent location above the roofline of the house.

Several other wool-on-linen samplers in a similar style—with brightly colored, broadly patterned, and highly stylized trees, flowers, and houses—feature the same teacher's name. They range in date from 1836 to 1852 and were done in western Pennsylvania. Recent research suggests that Tidball's school was located near the Bethel Presbyterian Church in Bethel Park, southwest of Pittsburgh.

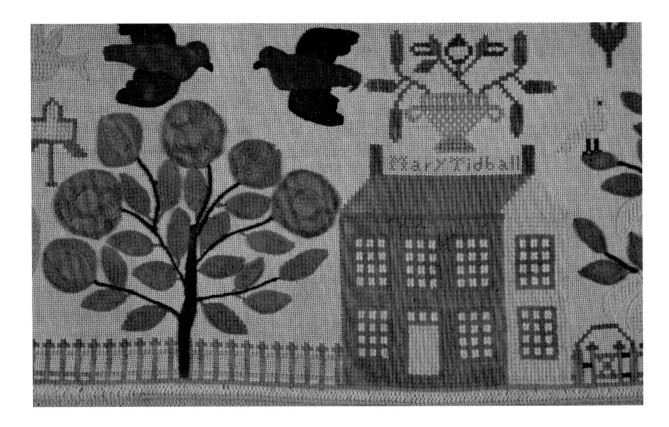

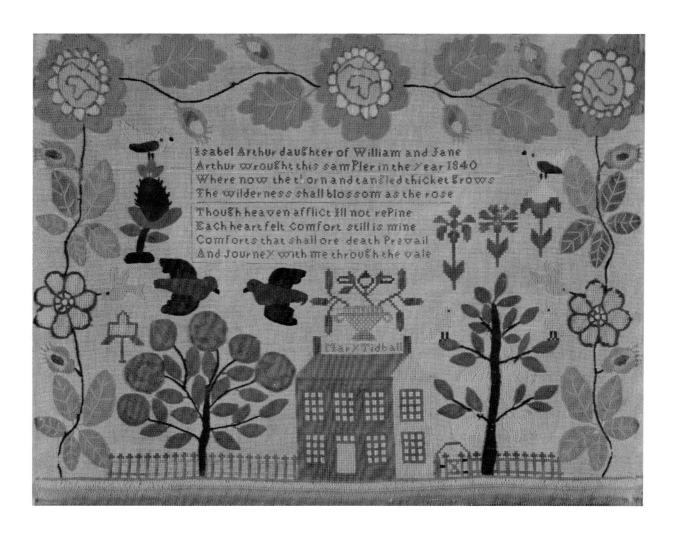

Sampler

1844

———

Sarah Maria Hunt (born 1830; death date unknown)
Hunterdon County, New Jersey
Wool on linen
16½ × 24 in.
2017.5.90

———

Born in 1830, Sarah Maria Hunt was, as her sampler details, the daughter of Samuel R. Hunt (born September 28, 1795) and Huldah P. Hunt (born April 10, 1794). Sarah later married Joshua A. Carter (also born in 1830). Sarah, her husband, and her mother are listed in the 1850 U.S. census as owners of a farm in western Michigan—in Keeler in Van Buren County. That census also states that all three were born in New Jersey.

This is one of three samplers in the Gail-Oxford Collection stitched in wool rather than silk thread. According to needlework scholars Dan and Marty Campanelli, the trio-of-strawberries border, unconventional lions, pine trees, checkered pots with flowers, willows, and fruit trees all link this sampler to Hunterdon County traditions in the first half of the 19th century.

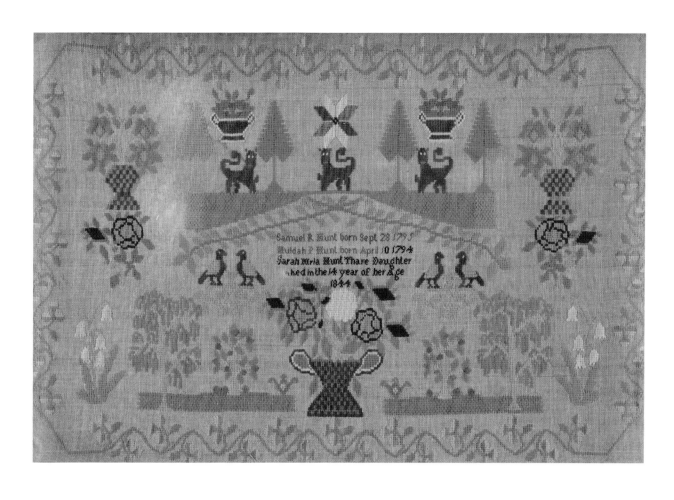

Samuel R Hunt born Sept 28 1795
Huldah P Hunt born April 10 1794
Sarah Mria Hunt Thare Daughter
ⁿ hed in the 14 year of her Age
1844

Tea service depicting Lafayette at Benjamin Franklin's Tomb

about 1824

Enoch Wood & Sons, Burslem,
Staffordshire, England
Earthenware
Teapot: 8½ × 11½ × 5¾ in.
Creamer: 5⅞ × 6¼ × 3¼ in.
Sugar bowl: 7¾ × 6¾ × 4½ in.
2017.5.47.1–.3

So-called "Historical Blue"—blue and white ceramic ware with detailed scenes of notable historical personalities and events—was immensely popular in America in the first half of the 19th century. Produced in potteries throughout the United Kingdom, its detailed decorative images were made using a transfer-printing process first introduced on British porcelain in the mid-18th century and widely used on earthenware after the 1780s. With images taken from a variety of sources, much of it was made for the American market. It reflected the level of patriotism and national pride that existed in the aftermath of the American Revolution and the War of 1812.

The image depicted on all three pieces of this tea service refers to the Marquis de Lafayette, a friend of George Washington and Thomas Jefferson and a key figure in the Revolutionary War. It commemorates Lafayette's much celebrated 1824 tour of the United States and, more specifically, his visit to the grave of Benjamin Franklin.

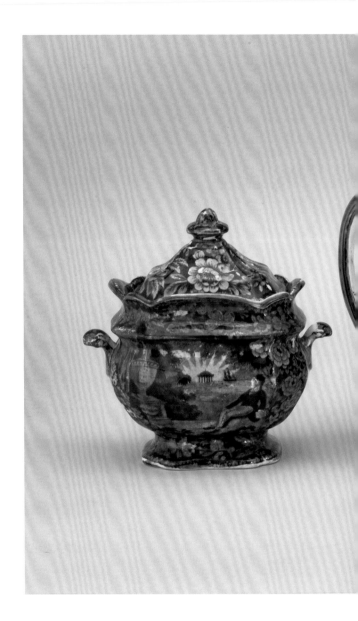

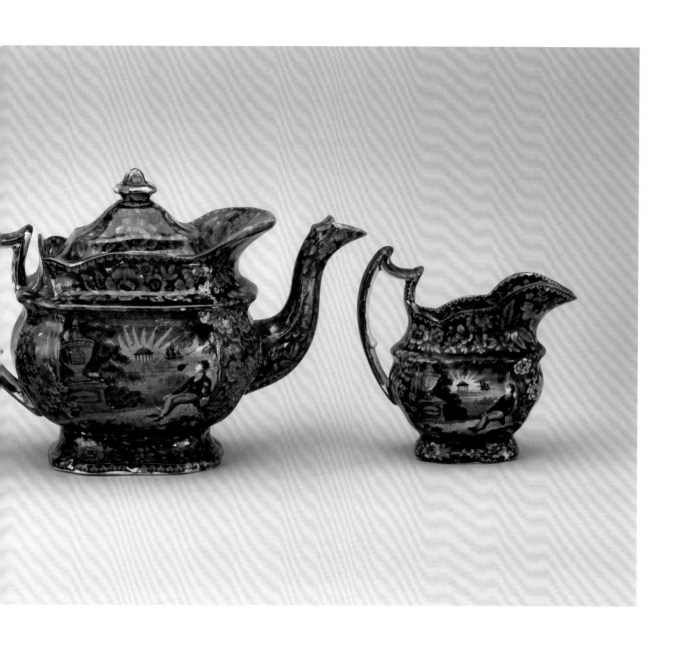

Portrait of William Ezra Wright and His Sister Amelia

ca. 1850

———

Joseph Goodhue Chandler (1813–1884)
Connecticut
Oil on mattress ticking
54 × 29½ in.
2017.5.25

———

Born in 1813, Joseph Goodhue Chandler trained as a cabinetmaker in South Hadley, Massachusetts. When he was in his teens, he studied painting in Albany, New York, with the portraitist William Collins (1788–1847). In 1840 Chandler married fellow artist Lucretia Ann Waite (1820–1868). In 1852 they settled in Boston, remaining there eight years until they moved to Hubbardston, Massachusetts, where they spent the rest of their lives. They are thought to have collaborated on several paintings throughout their long and productive careers.

Chandler is best known for his portraits of children, painted in three-quarter and full-length format. He also produced several double portraits of children, such as this one of William Ezra Wright and his sister Amelia, in which the siblings are depicted next to one another in a tender hand-in-hand pose.

In Chandler's portraits, his youthful subjects' facial features and hair are painstakingly described and crisply rendered. While the children are often fashionably dressed, their clothing is less detailed than their facial features.

Another characteristic of Chandler's work is his placement of his portrait subject in a beautifully expansive, loosely painted imaginary landscape. These landscapes often depict the golden glow of a setting sun in the distant background.

At the time of this painting, Amelia Wright was six years old, and her brother William was three. According to records accompanying the painting, their father was a farmer and a prominent member of the community in East Haddam, Connecticut.

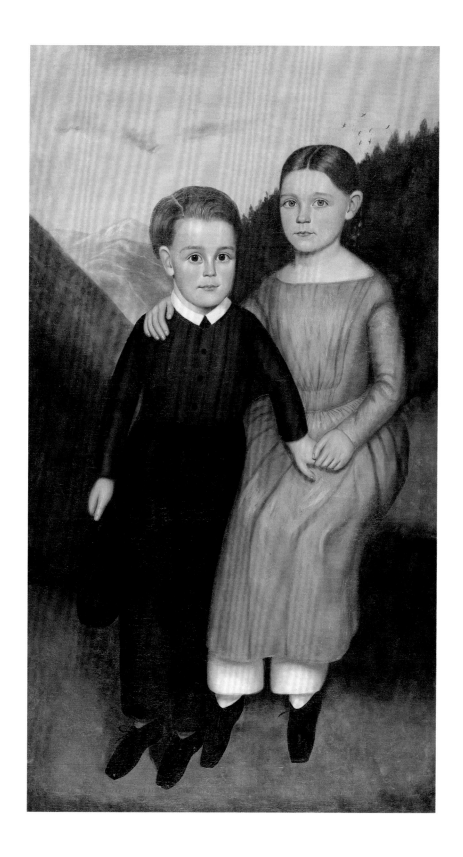

Leaping stag weathervane

about 1875

America
Copper with gold paint
36½ × 41½ × 7½ in.
2017.5.24

The weathervane, a fixture of the 19th-century American landscape, was placed high atop a house, barn, public building, or place of business. Indicating the direction of the wind, it provided information critical to farmers, sailors, and merchants alike, as their livelihood and well-being depended on the cycles of nature.

Weathervanes made in the first half of the 19th century were unique and handmade. However, in 1852, Alvin L. Jewell established the first commercial weathervane factory in Waltham, Massachusetts. His copper weathervanes were made in iron molds in two or more parts. After the metal was molded, the various component parts were soldered together. In response to the increasing demand for weathervanes, several other factories opened in the late 19th century.

Weathervanes were produced in a wide variety of shapes, sizes, and subjects, from animals (stags, birds, cows, horses, and pigs) to people (Native Americans, soldiers, and sportsmen) and objects (trains and horse-drawn carriages). This handsome leaping stag is a fine example of a late 19th-century weathervane.

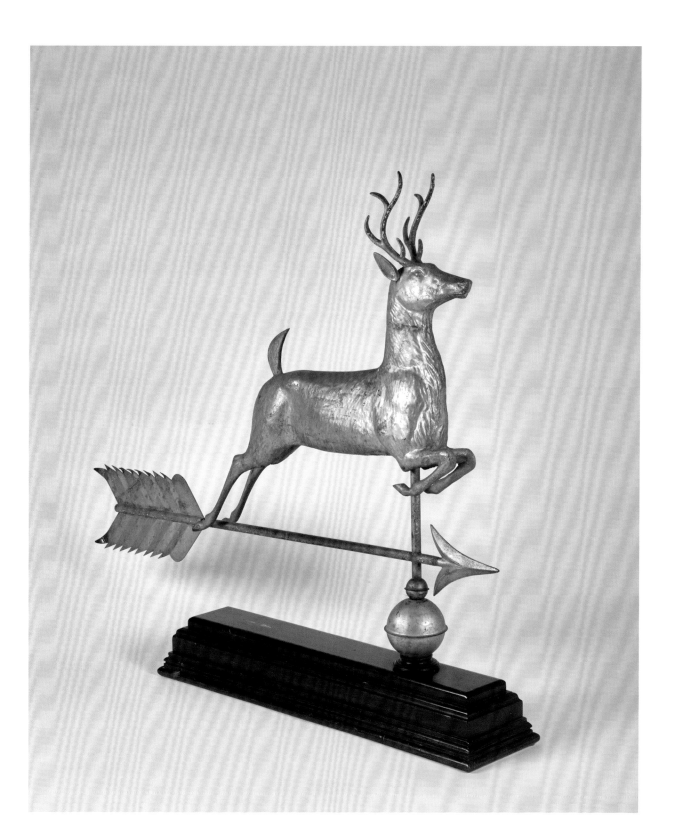

Floral Basket quilt

1840–50

America
Cotton
91 × 78 in.
2017.5.13

Typically used as bedcovers and produced in a wide variety of patterns and designs, hand-stitched quilts added vivid color to American households in the late 18th, 19th, and early 20th centuries. They also offered women a rare opportunity for creative expression, demonstrating the quilter's skills, imagination, and inventiveness.

Quilts usually comprise three layers joined together by intricately patterned needlework. The complex stitches seen in early American quilts create subtle linear patterns that often form a dynamic contrast to the quilt's bold overall design. The middle layer of the quilt, called the "batting" or "wadding," lends bulk and, more practically, insulation.

This selection of quilts made between 1840 and 1920 includes a wide variety of styles and patterns. Notable among them are the Floral Basket quilt, which combines squares of appliquéd printed chintz with applied patchwork designs, and the boldly patterned quilt in the design known as Sawtooth Diamond in a Square.

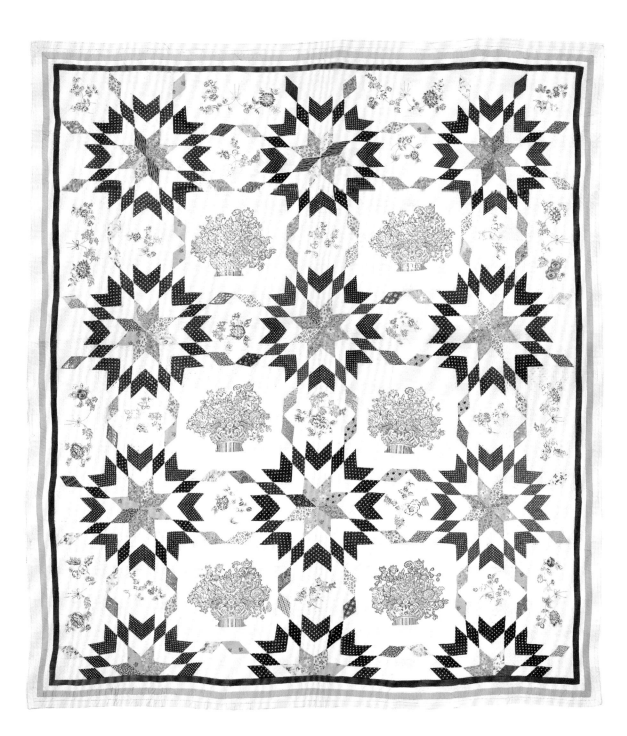

American Eagle quilt

about 1900

America
Cotton
95½ × 77 in.
2017.5.14

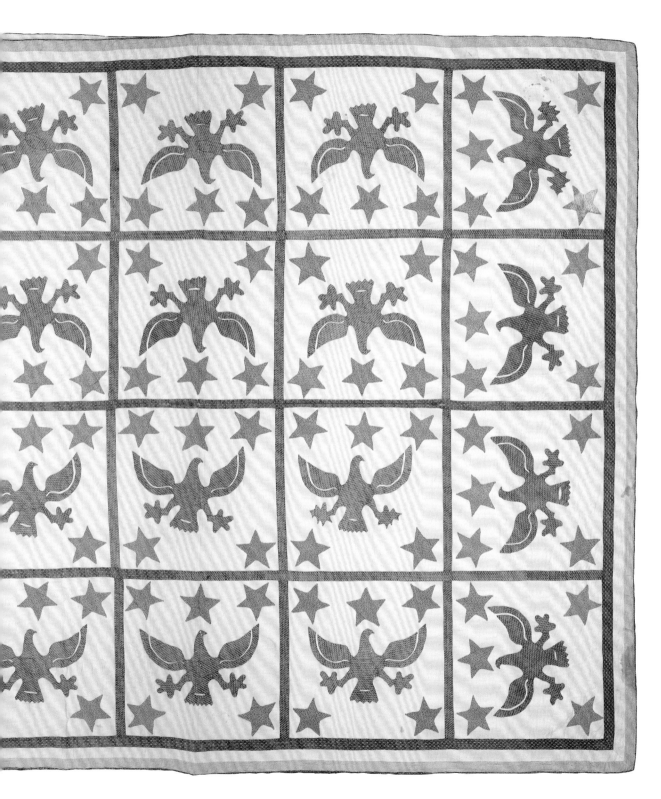

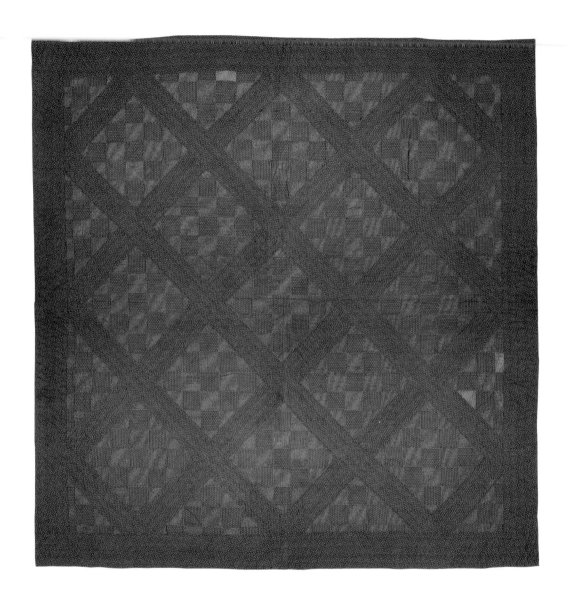

Red Blocks quilt

about 1900

———

America
Cotton
85½ × 85½ in.
2017.5.15

———

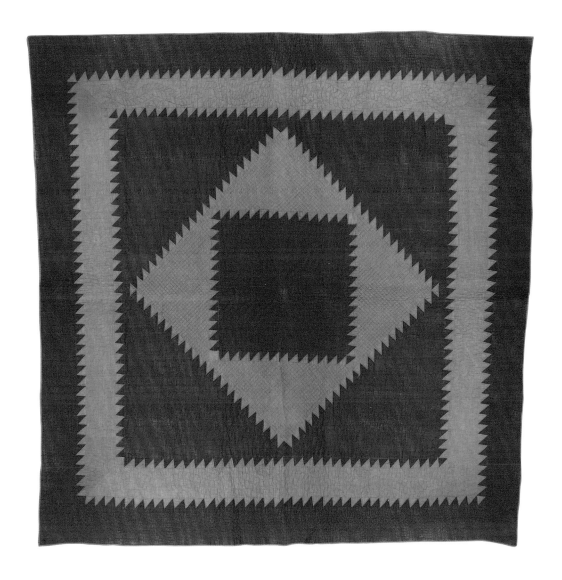

Sawtooth Diamond in a Square quilt

about 1920

Pennsylvania
Cotton
82 × 82 in.
2017.5.16

Jacquard coverlet

1847

Samuel Balantyne (1808–1861)
Lafayette, Tippecanoe County, Indiana
Cotton and wool
Overall (two loom widths joined):
90 × 74 in.
2017.5.17

All forms of weaving on a loom involve an interlacing of lengthwise elements (the warp) and crosswise elements (the weft). Weft fibers are typically carried across the warp with a shuttle. Prior to the 19th century, textile designs were worked out on grid paper and carefully executed by a weaver and an assistant. The so-called "Jacquard loom," invented by French weaver Joseph Marie Jacquard in 1804, made it possible to automate the patterning of the weave through the use of punched cards and corresponding mechanisms on the loom that manipulated the weft fibers to create the desired patterns. Jacquard's programmable system revolutionized the textile industry, making it possible to produce complex woven patterns quickly and cheaply. The system was introduced to America in the 1820s.

Born in Glasgow, Scotland, Samuel Balantyne, like many Scottish and English weavers who moved to America in the mid-19th century, probably served a seven-year apprenticeship under a master weaver before striking out on his own. According to the Balantyne family Bible, he married Jane Burt in 1829 and moved to the United States in 1832, settling first in Canonsburg, Pennsylvania, where the first two of the couple's six children—Elizabeth (b. 1833) and Abraham (1835–1904)—were born. By the time of the 1850 U.S. census, the Balantyne family had moved to Lafayette, Indiana. The census report describes both Samuel and his 15-year-old son Abraham as weavers. A decade later, in the 1860 census, Balantyne and his son are listed as farmers, indicating the seasonal nature of their work and the difficulty of supporting a large family by weaving alone.

The complex design of this coverlet was made possible by the punched card system and related loom mechanisms developed by Jacquard. Its bold and highly stylized patterns and its alternating floral and pictorial borders are distinctive characteristics of Balantyne's work. There is a smaller coverlet with a virtually identical design in the collection of the Columbus Museum of Art in Ohio. It too was woven by Samuel Balantyne.

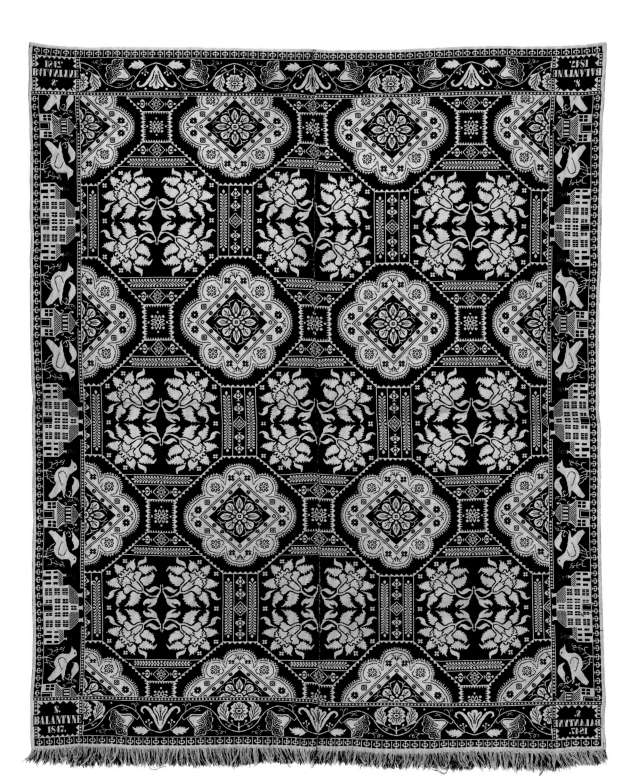

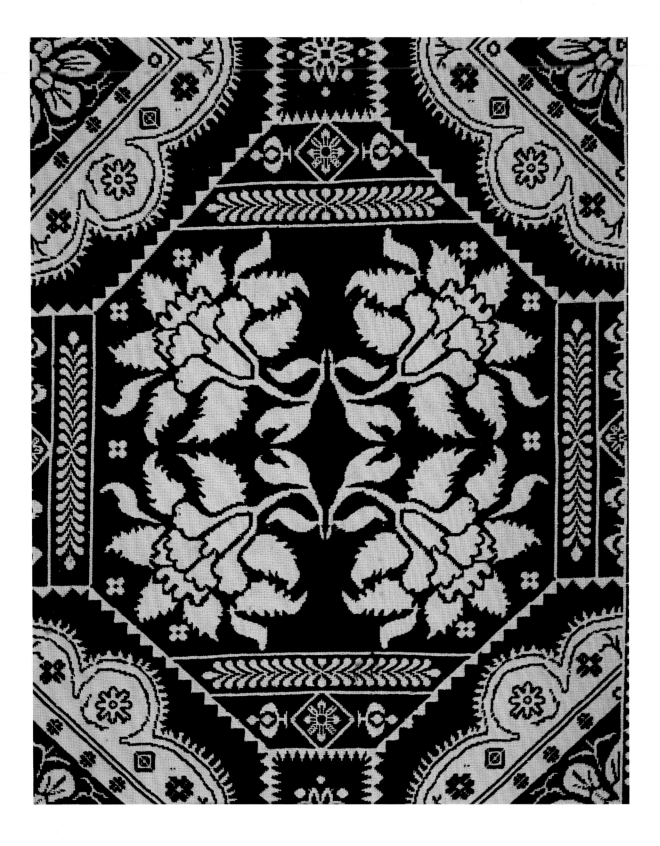

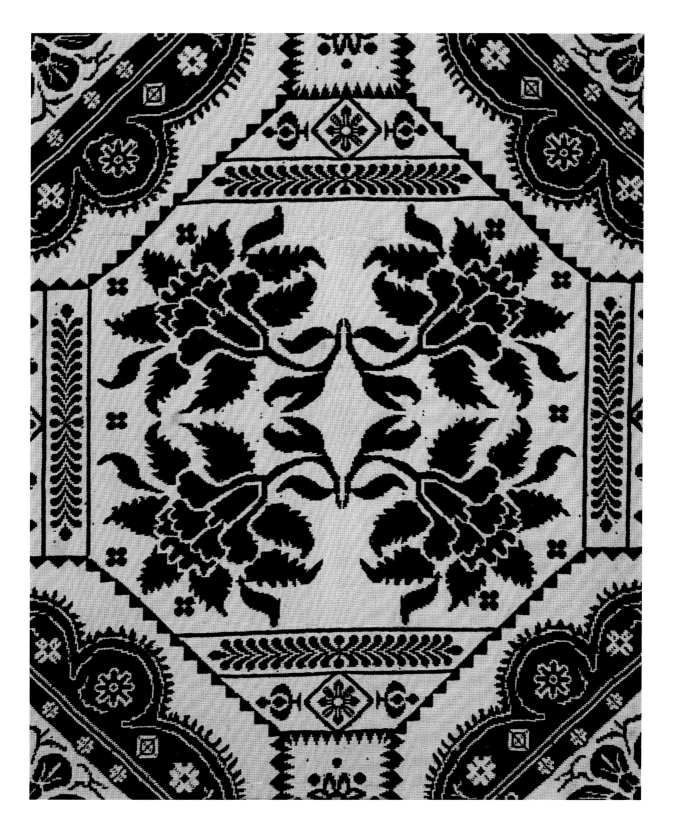

Major support for this publication has been provided by the Victor Gail Trust.

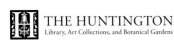

THE HUNTINGTON
Library, Art Collections, and Botanical Gardens

Published by The Huntington Library, Art Collections, and Botanical Gardens
1151 Oxford Road
San Marino, CA 91108
(626) 405-2100
www.huntington.org

Library of Congress Cataloging-in-Publication Data

Names: Henry E. Huntington Library and Art Gallery, author.
Title: Abundant harvest : selections from the Gail-Oxford Collection of American decorative arts at the Huntington.
Description: San Marino, California : The Huntington Library, Art Collections, and Botanical Gardens, 2018.
Identifiers: LCCN 2017059280 | ISBN 9780999652220 (pbk. : alk. paper)
Subjects: LCSH: Decorative arts--United States--Catalogs. | Decorative arts--California--San Marino--Catalogs. | Gail-Oxford Collection--Catalogs. | Henry E. Huntington Library and Art Gallery--Catalogs.
Classification: LCC NK805 .H42 2018 | DDC 745.09794/93--dc23
LC record available at https://lccn.loc.gov/2017059280

Produced by Lucia | Marquand, Seattle
www.luciamarquand.com

Managed by Chad Alligood
Copyedited by Jean Patterson
Proofread by Ted Gilley
Publication coordinated by
 Lindsey Hansen
Principal photography by John Sullivan
Photography on pp. 32, 33 by Fredrik
 Nilsen
Designed by Zach Hooker
Typeset in Kepler by
 Integrated Composition Systems
Color management by iocolor, Seattle
Printed and bound in China by
 C&C Offset Printing Co., Ltd.

Note to the reader:

Dimensions are given in inches; height precedes width or length precedes depth or diameter. Measurements often reflect maximum dimensions.

Front cover: Detail of sampler (pp. 108–9)

Back cover: Detail of chest of drawers (pp. 78–79)

Front flap: Detail of desk (pp. 52–53)

Back flap: Detail of chest of drawers (pp. 114–15)

Page 1: Detail of sampler (pp. 86–87)

Page 2: Detail of shelf clock (pp. 106–7)